*Do you remember the
best summer of your life?*

Summer
at
Tiffany

MARJORIE HART

HARPER **LUXE**

An Imprint of HarperCollinsPublishers

FIRST HARPERLUXE EDITION

Library of Congress Cataloging-in-Publication Data
Hart, Marjorie, 1924–
 Summer at Tiffany / Marjorie Hart. —1st ed.
 p. cm.
 ISBN: 978-0-06-118952-4
 ISBN-10: 0-06-118952-9
 1. Hart, Marjorie, 1924– 2. Tiffany and Company—History.
3. Department stores—Employees—United States—Biography. I. Title.
 HF5465.U64T544 2007
 381'.141092—dc22
 [B] 2006047225

ISBN: 978-0-06-123308-1 (Luxe)
ISBN-10: 0-06-123308-0

13 14 15 ❖/RRD 10 9 8 7 6 5

FOR MARTY

I have changed the names of some individuals, and modified identifying features, including physical descriptions, of other individuals in order to preserve their anonymity. In some cases, composite characters have been created or timelines have been compressed in order to further preserve the privacy of dear friends and to maintain narrative flow. References to real people, events, establishments, organizations, or locales have been re-created as I remembered them best from memory. My quest was for accuracy, though it might have been hindered at times by the passage of sixty-odd years. Overall, I sought to protect the privacy of the individuals profiled in these pages and to tell my story to the best of my recollection without damaging the integrity of the story or those who lived it with me.

Author's Note

*S*ummer at Tiffany is the story of a summer that I have never forgotten. Whenever I had a down moment in my life, the simple recollection of memories from the summer of 1945 was always sustaining. From the faint smell of the Hudson River from the top of a bus, to climbing the steps from a dark subway into the light, to the Tiffany show windows of diamonds spilling from velvet cases and the welcoming smile of the gentleman who clocked us in each day—these remembrances of my *Summer at Tiffany* continue always to embrace me, and bring a smile to my face.

I began writing about that summer in spare moments, on grocery receipts and shopping lists, or on the backs of envelopes in the middle of the night until I began

to meet with other writers who encouraged me. In the last few years, through workshops, by mail, or over coffee, I began believing that everyone has a spellbinding story worth telling—something these other writers had known all along.

Reconnecting with those who experienced that summer became the most heartwarming part of writing these pages. To find that Marty's memory squared with mine was reassuring, and the discovery of new details, the surprises we uncovered, the laughs we enjoyed, erased the years that had passed. I am grateful for the gracious response of the individuals I found after sixty years, their contributions and permission to add new material, cards, and photographs. I wish to protect the privacy of dear friends, and therefore for those I couldn't reach or who are no longer living some names and identifying details have been changed. My quest for accuracy may have been hindered by the passage of sixty-odd years; if so, please excuse my error!

What a golden era writing and publishing *Summer at Tiffany* has opened up for me and for those who have believed and allowed this story to be told.

Acknowledgments

There are many individuals who have it made it possible for me to write this story: those who experienced the summer of 1945 with me, the writing of it, and the people who inspired me.

My greatest thanks to Jennifer Pooley, my amazing editor at William Morrow, who discovered my manuscript (by its first ten pages alone) at the San Diego State University Writers Conference, and magically created a book. Her constancy of faith, her insight, and her unfailing enthusiasm—from New York City to San Diego—has cheered me. Her clarity of vision and perceptive contributions have made my memoir a reality. There would not be a book without her.

To also have the extraordinary talents of Kevin Callahan and Sharyn Rosenblum, as well as their visionary

commitment, has been a revelation. Special thanks as well to Emily Fink and to Carla Parker for their passion, to Maryann Petyak for her gift of the catalog presentation, and to Michael Morrison and Lisa Gallagher, who believed from the first two chapters. I am grateful to the entire team at William Morrow for their intelligent guidance of this book through the various channels of their expertise.

My gratitude to Melissa Houtte, who collaborated and brainstormed with me, and made contributions that shaped the manuscript. And to Beverly Trainer, my mentor, who edited and critiqued my drafts and rewrites, for her important contributions, and her insistence that I keep my voice.

My most heartfelt thanks to those who experienced that summer and have shared their recollections so generously.

To Marty, I dedicate this memoir; with her undaunted spirit she led me through the Fifth Avenue entrance to Tiffany & Co. She has since contributed and recalled details (some to the last penny!) of that unforgettable summer. I also appreciate the interest of her three sons, Bill, Bob, and Jim, as well as Jim's wife, and their sons, Matthew and Scott.

A special thank-you to Mickey (Margaret Shuttle-

worth Vernallis), who found our Manhattan apartment and included us as part of her family. The bond I felt with her mother, a fellow cellist, and her warm hospitality will never be forgotten.

My greatest thanks to Jim, who graciously responded to letters and provided fascinating information. I treasure those fond memories.

My deep gratitude to: Katherine and Dick (Richard) Munsen for their continual support, for information from their book *Bail Out Over the Balkans*, and for my sister's inspiring writing; and to Phil (Philip) and Diane Jacobson for their encouragement and support and never-to-be-forgotten gift in 1945; to Bill Craig (William Craig III), who recalled the details and kept me in tune with New York City with the ongoing gift of *The New Yorker*; to Albert Donhowe, who not only shared the photograph of his brother, Paul, but his memories of Story City events as well. And Kenneth Jansen, whose father was a chauffeur for the Tiffany family and shared memories of when he lived above the Tiffany garage as a young boy.

In addition, my thanks to Becky Ryan, at the SDSU Writers Conference, who diligently paired my manuscript with Jennifer Pooley, and also to Leslie Koch and Steve Dolan for their support.

Thanks to Tiffany & Co., and the unforgettable employees of 1945. Their memory and spirit brighten my day whenever I enter a Tiffany store.

My thanks for the support of those who waded through the early drafts and offered critiques: Gary and Priscilla Haynes, who made corrections and provided constant encouragement; Bill and Nora Smith for their contributions, expertise of Minton China and New York City life, and gourmet meals; Yvonne Nelson Perry, who led and critiqued at her writer's workshop in Coronado and her home; Joan Oppenheimer, who advised me to "put myself in the story"; Susan Reed at the Cuyamaca writers' class; Arnold Flick for his ideas; and Lita Manson, Ed Husjak, and the late Bob Michaelis, whose writing I admire.

My inspiration to write this memoir belongs to my family: my daughters, Susan Wilson, Elise Cassidy, and Jane Myers, and their husbands; and my son, Bob Hart, for his wise suggestions; my late husband, William Hart; and my parents, who would have been so proud! My grandchildren—Kirsten, Eric, and Katherine Wilson and Jacqueline and Sarah Myers—have helped me to remember what it is like to be young. Also Kevin, Cara, Brian, and Erin Cassidy, who critiqued as well. My stepdaughters also encouraged me: thanks to Cynthia

Vitas, Lisa Sagat, and Teri Davies and their husbands and children: Alison and Ricky Sagat and Vince, Adam, and Alyssa Davies. Also to my in-laws, Ann and Charles Johnston.

I am especially grateful to my chamber music friends, who kept me grounded and nurtured me with Haydn, Mozart, and my favorite composers.

Finally, my deepest thanks and love to my husband, Peter Cuthbert, my best friend and companion, who read the manuscript, corrected, critiqued (he's a stellar grammarian!), and kept me alive with takeout dinners!

Summer *at* Tiffany

Chapter One

From the top deck of the bus, Marty and I were mesmerized by Fifth Avenue as we watched glamorous stores spring up like pages out of *Mademoiselle*. Bergdorf Goodman. Bonwit Teller. Cartier. De Pinna. Saks Fifth Avenue. Peck & Peck. We knew all of the stores even if we had never been through any of their doors—or even seen a store bigger than Younkers in Des Moines!

When the Empire State Building loomed ahead, we were speechless. I felt like a princess on a Fourth of July float, looking at my kingdom, which in this case was a landscape of high-fashion show windows, screeching traffic, and the tallest building in the world.

We couldn't stop to sightsee. We were looking for a job.

Marty was holding a Manhattan map in her lap, while I held on to my hat.

"Get ready." She pointed. "Thirty-eighth Street is coming up!"

We barely made it down the narrow circular stairs before the bus took off again. In my eagerness to cross the street, I stepped into the path of a Checker Cab. A man pulled me back and Marty screamed. My heart lurched as I tried to catch my breath. The light changed from red to green, red to green, before I found the courage to step off the curb and cross the street.

I felt calmer as we entered Lord & Taylor. It was a historic moment. We could be working behind one of their glistening counters as early as tomorrow. In a trance, I followed the scent of Chanel No. 5 past the cosmetics counters and the racks of two-piece bathing suits, Hawaiian dresses, and turbans with sparkling rhinestone clips. By the time we reached the elevator, I had mentally spent my first paycheck.

Opening the door to the employment office, I stared in disbelief. Marty was wide-eyed. There, cramped into a vestibule with overflowing ashtrays, were over thirty girls waiting for applications, some crouched on

the floor. Included in that group were a Powers model type in a sleeveless pink linen dress; a pert brunette teetering on four-inch white ankle-strap heels; and two elegant girls with white shantung jackets. Looking at us, they smiled, giggled, and laughed. My face flamed as we squeezed into the line.

We were garbed in black. Totally. Black dresses, shoes, and cartwheel hats. Our inspired outfit had been copied from a glossy ad in *Vogue,* but that sweltering day, we looked like characters out of a Tolstoy tragedy.

Marty and I gave each other The Look. With heads up, we peeled off our white gloves to fill out our applications, and smiled back at the girls. Little did they know the kind of pull we had.

The harried manager didn't bother to look up when we handed our applications in.

"Come back next fall," she said crisply.

Next *fall?* She's dismissing us without reading our applications? She doesn't know our *connections?* I was furious! We'd counted on this job. We needed it for the summer. Now.

"Excuse me," I said. "We have friends working here"—my voice was so tight, I scarcely recognized the anger in it—"and an important reference—"

She shook her head, filing our applications without glancing at them. Or us.

"Don't worry, Marjorie, this isn't the only big deal in town," Marty said on the way out.

Beads of sweat trickled down my face. We trudged in and out of a dozen stores, waiting in lines and filling out applications. When we reached Saks Fifth Avenue the management only shooed us away. I couldn't believe it! What was this wild rumor that finding a job in Manhattan was easy?

It had all started a month ago, when three of our sorority sisters had landed fabulous jobs at Lord & Taylor. *Lord & Taylor!* The day they received the letters, they shrieked and celebrated the news all over the Kappa house until our housemother put the kibosh on the wild conga line they had started.

"Come along," Anita had urged every Kappa. "Getting a summer job in Manhattan is a cinch!"

The next thing we knew, every girl at the University of Iowa wanted a train ticket for the East Coast to find a high-fashion job.

"We can get on a train for New York, too," Marty said in our dorm room.

"*New York City?*" She couldn't be serious. Summer

school was beginning in a few weeks and I was sure that her savings were as meager as my own.

"You bet," she said, pitching our summer schedule in the wastebasket. "All we have to do is collect Coke bottles—there's tons around the campus. Enough for a couple train tickets." Gesturing with her cigarette, she added, "Think of the fun we'll have—Broadway shows . . . nightclubs . . . and those beaches!"

That struck a chord. I'd never been east of the Mississippi River and had always wanted to see the ocean. Remembering the last stifling Iowa City summer that only a row of corn could love and the dim social life at Whetstone's Drug Store—now that nearly every eligible man was either fighting in the Pacific or waiting to be shipped out—it wasn't difficult to start collecting those empty Coke bottles. Leave it to Marty. Scooping up those bottles was fun, frenzied, and frantic. All we needed was that job.

Now, standing outside of Saks Fifth Avenue, Marty shrugged. I was scared. We climbed back on the next bus. The upper deck was crammed with servicemen, shoppers, and kids with ice cream cones dripping from the blazing June sun.

Two navy lieutenants tried to stir up a breeze with a

newspaper while they debated the merits of President Truman. I fanned myself with my hat. A red-hot blister forced me to take off my shoe.

Marty was undaunted. Sitting close to the rail, she studied each block looking for the next strategy like some four-star general. The stores were becoming smaller, more exclusive, and more unlikely. Hattie Carnegie? Good heavens.

Suddenly, Marty jumped up. "There's Tiffany!"

"Tiffany? The *jewelry* store?" I exclaimed.

Marty was halfway down the stairs of the bus before I could find my shoe. On the corner of Fifth Avenue and Fifty-seventh Street, the sun illuminated a sleek new building, seven stories high with the elegant sign TIFFANY & CO. In the showcase window was a brilliant diamond necklace with matching ear clips mounted on black velvet.

"*Marty!*" What was she thinking?

She only smiled and checked the angle of her hat in the reflection of the window.

"So?" Marty laughed, and swept through Tiffany's wide revolving door.

I followed.

Inside, it was cathedral-like: spacious, serene, and cool. It made me gasp. On the paneled main floor,

marble-framed mirrors reflected the light from the windows on the opposite wall. Diamonds shimmered from glass counters as if they were alive, while solemn, dignified men watched over them like sentinels.

There we were, two long-limbed, blue-eyed blondes marching down Tiffany's center aisle in our shiny black pumps. Only the *click-clack* of our shoes broke the silence. I treaded cautiously—feeling the scrutiny of the salesmen—while Marty clipped along like a golfer on a fairway. As we reached the end of the aisle, our steps slowed. Where was the employment office? The personnel office? To the right, a jowly man with bushy eyebrows in a cashier's cage glanced at us with an amused smile.

I approached him, my face burning in shades of red.

"Could you please direct us to the employment office?" I asked, my voice shaking.

"I'm sorry, miss," he said kindly. "Tiffany does not have an employment office." Nodding to a man nearby, he added, "Our superintendent is over there. Perhaps he could help you."

A tall, stoop-shouldered man came forward. "May I help you, ladies?"

"We would like to apply for work," Marty said.

"Work?" he echoed, as if we were speaking in tongues.

"A summer *position*," I clarified.

Silence. An uncomfortable silence. I looked down, as if fascinated by the design of their parquet floor.

Finally, the superintendent motioned to a door. "Please come this way."

We left the main floor for a narrow corridor, which took us to a small paneled office. He introduced us to his secretary, a fiftyish woman with tinted hair pulled back in a severe bun. She sat behind a desk, typing.

"These young ladies are looking for summer work," he said to her. She looked up; her eyes widened. "What kind of job are you looking for?" he asked us.

"We could sell jewelry," I said. What else?

His eyebrows arched and the secretary pursed her lips, suppressing a laugh.

"At Tiffany, we only have salesmen on the floor," he said. "What's your work experience? Do you know shorthand?"

Marty explained that we were students from the University of Iowa and her major was in business and economics. She said that she had worked in a defense plant for the summer, and had administrative experience (as president of the university's Business

Club) and (because her father was a lawyer) some legal experience.

When he looked at me, I hesitated. I was terrified I'd say something idiotic and look like a nitwit. I'd never been president of anything.

In a small voice, I answered, "I've worked part-time at a campus dress shop. I'm a music major . . . and play the cello." As if, wow, the cello would make the difference.

The superintendent looked puzzled.

"And you girls have come all the way from *Iowa*?" he asked as he looked at the secretary and rolled his eyes.

"We're here for the sum-mer," Marty answered, enunciating every syllable, "living on Man-hat-tan."

"Near Columbia University," I added, so he'd know our classy address.

The secretary stared as if we were a couple of crazed runaways. The superintendent glanced at his watch.

"I'm afraid there are no openings at Tiffany—for *girls*," he said, putting all his emphasis on that last word.

"I see," Marty said, meeting his gaze, while I looked for the door. "But we have an important business reference for your president."

Marty—there are no openings!

"*Our* president? *President Moore?*" he asked, stepping back.

"Yes." Marty repeated coolly. "President Moore."

The secretary pulled off her glasses. The superintendent reached for the telephone. I swallowed hard, stunned.

Ohmygosh. I clamped my teeth; I felt nauseous. The bewildered superintendent had left, the secretary sent us furtive, frowning glances, and even Marty looked apprehensive, tracing a circle on the floor with the toe of her shoe.

Our hope was our reference, Mr. Carl Byoir. We had met him the day before.

"My dad said to look him up, first," Marty had said. But we couldn't find his address until we stepped back from the building and looked up to where his name was etched in stone across a tall building on Fortieth Street, near Madison Avenue: CARL BYOIR & ASSOC.

"Good heavens, Marty—*who is he?*" I said, my eyes never leaving those perfectly carved letters.

"I have no idea," she said, staring at his name. "My dad only told me he'd gone from rags to riches."

On the top floor, we were ushered into his sumptuous office with a view overlooking the city. A short,

balding man, he had the warmest smile that we'd seen since we'd arrived in New York City.

"I hear you girls are from Iowa U.," he said. "I've been expecting you." He shook our hands and motioned us to sit across from his enormous desk. "University of Iowa is the greatest college in the world—don't you forget it!"

While Marty relayed the news about her father's partner—a man called "Stub" Stewart whose nickname came from his days as a football player on our college team—I stared, amazed, at the wall behind his desk. It was filled with photographs of Mr. Byoir with President Roosevelt. Some were at a mansion with Fala, the president's dog, and one beside a huge tiered birthday cake. I hoped Mr. Byoir would explain them to me, but he was in his element recalling his college days. He had been manager of the *Hawkeye,* our college yearbook, and he told us that it was its success that had paved his way to New York City. He asked where we were living. How did we like the city? Would we like to go nightclubbing? *Would we!*

"So where are you girls looking for work?" he asked, leaning back in his chair.

When Marty mentioned Lord & Taylor, he said, "Oh, that would be a good place—my wife loves that

store. Though Tiffany is *really* her favorite." Then he winked. "I've been working for Tiffany's ever since I married her!"

Marty and I exchanged knowing glances. *So that's what he did.*

Before we left, he said, "My secretary will give you a card for a reference."

I was counting on that card, our ace in the hole.

When the superintendent reappeared, he ushered us to a special elevator. Not a word was spoken. He tightened his paisley tie, pulled his handkerchief from his breast pocket and unfolded and refolded it, cleared his throat, wiped his palms, replaced his handkerchief, and checked his tie again. Stage fright. I knew the signs. I vowed to keep my mouth shut and let Marty do the talking.

Reaching the top floor, the superintendent led us into an elegant lounge with velvet upholstered chairs and delicate French tables holding lavish accessories: a silver cigarette lighter, a cloisonné ashtray, and a letter opener mounted with gems. Along with an application, he handed us each a silver fountain pen.

When we finished, he checked our applications and turned to Marty.

"Miss Garrett, please come with me."

Only Marty? We were being interviewed *separately?*

I panicked. My head was swimming and my hands began to feel clammy. Suppose I'd be asked things about Mr. Byoir that I didn't know? Without Marty to do the explaining, I knew I'd be left stuttering and stammering. And if they asked for work experience, boy, was that dismal: straightening neckties at my father's store, selling slips and girdles (oh no!) and bathing suits at Towner's dress shop, and playing wedding gigs on the weekend. On second thought, they probably wouldn't know what a gig was, or a cello. I knew darn well that mentioning the cello would evoke a baffled stare or an amused snicker. There wasn't one impressive thing to talk about—if I could talk at all! What a pair we were: me with the squeaky voice, and the superintendent clearing his throat.

They were back. Marty smiled and rolled her eyes.

What did she mean?

"Miss Jacobson," the superintendent said.

My legs trembled as I followed the nervous superintendent down the hall. We walked in single file, funereal style. Before he opened the door, I took three deep breaths, put on my gloves, and tilted my hat like Joan Crawford.

Standing at the far end of a table—the length of a bowling alley—were two distinguished-looking gentlemen. The superintendent introduced the taller one as President Moore and the younger, round-faced man as a Tiffany nephew. The superintendent sat next to me, halfway down that long polished table. He was uneasy. I was petrified. I couldn't have been more scared if it was my Carnegie Hall debut.

President Moore gazed directly at me, holding my application.

"Miss Jacobson, could you please tell us why you decided to find work here?"

That was easy.

"Marty—Martha Garrett—and I were looking for a summer job." I tried to sound as natural as possible, but my voice was quivering. "When we saw your store—well, we jumped off the bus and came right in."

The younger man smirked; the superintendent cleared his throat. I wished I could bite my tongue off.

"I see you're from Story City, Iowa," President Moore continued. "How did you hear of the Tiffany Company?"

"From the *National Geographic*—the ad on the first page of the magazine." They seemed to like that answer. And it was true; when I was a little girl, my

father would always open the latest issue and read it to me. The first page had glittering jewelry and he would point and say, "Tiffany."

"Your father's name is Alfred Jacobson?"

"Yes, sir."

"He has a clothing store?"

"Yes, Charlson Clothes Shop; it's a men's clothing store—with Hart Schaffner & Marx suits, Stetson hats, and Florsheim shoes—" I heard myself babble on, seizing the opportunity, feeling sure they were wearing the same top lines. Certainly, Florsheim shoes.

"What is your nationality?"

"I'm one hundred percent Norwegian," I said proudly.

When the president lifted my application, I caught a glint of gold cuff links.

"Can you tell me how you pronounce this name—Mr. B-y-o-i-r?"

"Byoir," I said, pronouncing it so it sounded like *Buyer.*

"How do you happen to know him?"

"We met Mr. Byoir yesterday—through Martha Garrett's father's partner."

"What does he do?"

Was this a trick question? "Mr. Byoir told us—he works for *you.*"

The superintendent stared, President Moore smiled, and the nephew laughed out loud.

"Thank you very much, Miss Jacobson," President Moore said as he stood up. "I believe that is all. We're delighted to meet you and Miss Garrett."

They smiled at me as we left, but when the door closed I could hear them laughing. Honestly! What had I said that was so funny? Which ill-chosen remark had done me in?

The superintendent escorted us back to the lounge and left us alone. Before I could sit down, Marty started talking, her eyes sparkling.

"Honest to God—you're *not* going to believe this! President Moore said, 'I see you're from Des Moines. I know that city—I was stationed there at Fort Dodge during the First World War.' 'What a coincidence,' I said. 'My father was at Fort Dodge, too. Maybe you knew each other,' and he said, 'It could be. Ask your father.' Wait till I tell—" She stopped short as the superintendent reentered the room.

"We'd like you girls to come back next Monday. There may be a job possibility."

Next Monday? A *possibility?*

I didn't notice the doorman or the blast of heat when we sailed through the revolving door back onto Fifth Avenue.

106 Morningside Dr.

Dear Family,

Guess what? We may have a job at *Tiffany's!!*
Can you believe it? We'll find out this Monday—
keep your fingers crossed! It's only a possibility,
so don't you dare tell a soul till we know for
sure!!

That isn't all—remember how Marty's father
wanted us to meet Carl Byoir? He's *very*
important—you should see the pictures of him
with President Roosevelt, and with Fala. Also, he
works for Tiffany's—isn't that a big coincidence?

Our apartment is absolutely perfect—a studio
couch in the living room for when the Long Island
girls visit, a walnut desk like Aunt Charlotte's,
darling ruffled bedspreads in our bedroom, and
even a pop-up toaster in the kitchen! Talk about
lucky!!

Don't worry about us. This is *not* a dangerous
town!

Love, Marjorie

But they would have been worried sick if I had told
them that after finding the correct subway home, we'd
gotten off at the wrong stop.

Disoriented, we had wandered not more than thirty

steps from the station, looking for any landmark we recognized, when a policeman caught up with us.

"Hey—where'd you think you're goin'?"

"Morningside Drive," I said, in a trembling voice.

"You're on Lenox. Morningside Drive's on t'other side of the park. Follow that street," he pointed, "and don't you be comin' down here again."

"For cripessake!" Marty said, striding off. I looked at the long hill before us, ready to cry. My feet throbbed, my dress stuck to my back, and I remembered my parents' dire warnings about the big city after dark: robberies, kidnappings, and murders!

But Lenox did not look dangerous. Kids were playing in the street, splashing in water, laughing and squealing. With blisters digging into my heels, I envied them—oh to go barefoot in hundred-degree weather. Halfway up the hill, Marty, who had started out like a Camp Fire girl on a relay race, was wilting.

"If we end up in New Jersey, let me know," she muttered.

When I finally caught sight of Morningside Drive and could see the Seth Low apartment building in the distance, tears ran down my sweaty face. Thank heavens! Marty was resting against a fence. We looked at each other and would have laughed, had we had the energy.

The desk clerk at our apartment building didn't acknowledge us when we straggled in, carrying shoes, hats, and grubby gloves. The elevator man sniffed. But when we collapsed in our apartment, it felt like the Astor.

Chapter Two

We were sitting in our sparsely furnished living room, eating day-old deli sandwiches, when the phone rang. Marty ran to answer it.

"Hello . . . Sheila! How's life at Lord and Taylor's?"

I slumped back on the studio couch and put my bare feet up on the pillows, staring with morbid fascination at my blisters.

"Really? You're getting *discounts*?" Marty was saying. "Sure, we applied there—great store—but we're thinking of another place."

I sat up and clapped my hand over my mouth, to remind Marty.

"Oh," Marty continued in an offhand voice, "just a little shop we ran into up the avenue." She winked at me.

"*This* weekend? All of you? Yeah, we have a studio couch in the living room, but golly—"

"What's going on?" I mumbled, my mouth full of bologna.

"Sure, we're close to Columbia . . . what midshipmen? Ohmygosh! We had no idea!" Marty signed off, "Okay, you bet; we'll see ya," and then hung up the phone and slid into the worn chenille chair.

"You won't *believe* this," she exclaimed, breathlessly. "Midshipmen are at Columbia!"

I jumped up. *Midshipmen?* "No kidding—so *that's* why the girls are dying to spend the weekend."

"Why else? That—and to see our apartment."

"Don't you dare spill the beans about Tiffany's—"

"Not till we sign on the dotted line—then watch out!" Marty laughed. "They'll turn every shade of green."

"They'll scream! Can you stand it?"

Even though my blistered feet felt as if someone had boiled them in oil, I started laughing. How could we be that lucky? Sheila came from Long Island, and had invited several Kappa friends to spend the summer. All the talk had been about Lord & Taylor, Broadway theaters, Rockefeller Center, the Stork Club, El Morocco, Sardi's, and the beaches. Now, the hot spot in Manhattan would be our apartment.

That said, our little nest was far from perfect. The view from our living room window was a brick wall, it was stifling hot, the twin beds sagged, and the kitchen was so small you could barely open the fridge door. *And* the phone rang night and day—courtesy of the Checker Cab's advertised number, one digit away. But despite its faults, we adored our tiny abode. To have our own Manhattan apartment without a parent or housemother within a thousand miles was a college girl's dream.

That night in our room Marty propped the pillow behind her head, balanced an ashtray on her chest, and took out a cigarette, "Don't be surprised—I'll bet the girls will be here every weekend."

It was okay with me. Sheila with her boundless energy and flair for funny accents could liven up any crowd. And our friend Joannie—never a blond hair out of place—was a good sport, though her mind was never far from her boyfriend, a flier in the Pacific. Anita was a whole other story. She'd attended a prep school, could speak French fluently, and smoked long, sexy Marlboro cigarettes with "red tips for the hot lips" so her lipstick marks wouldn't show. Her pet name for Marty and me was "the sisters."

Compared to her own antics, she might have meant that we were stodgy like nuns, but Marty and I were

mistaken for siblings all the time. We were the tallest girls in our sorority, combed our long blond hair in a Lauren Bacall style, wore the same kind of scuffed saddle shoes, and as one sweet guy put it, "You're the gals with Betty Grable legs." But the similarity between Marty and me ended there.

I came from Story City, Iowa, a town so small that everyone was known by a nickname: "John's Lena," "Mrs. E.L.," or "Hop Jacobson"—my father. I was called "Katherine's little sister," and blushed with pride every time I heard that, for it was the closest I'd come to celebrity status. The *Des Moines Register* had run a picture of Katherine when she was five, at a state diving exhibition, and later in high school when she won the National Music Contest as a violinist. She was the achiever, and my younger brother, Philip, was industrious and adventurous, while I was content to sit back and watch it all happen as the middle child.

However, when I changed colleges for the University of Iowa, no one knew her, or me, and I floundered like a lost soul until I met Martha Garrett.

Martha "Marty" Garrett was not only a popular girl on the University of Iowa campus, she was from Des Moines, the capitol of Iowa, and lived in a white brick Colonial home on a two-acre lot in a wooded area. She knew her way around the Wakonda country club,

played a good game of tennis, enjoyed a whirlwind social life, wore beautiful sweaters, and had traveled as far as Mexico.

On the other hand, my hometown was so small that I had no idea what street I'd lived on until years after I had finished college. My social life in Story City had revolved around Luther League meetings for teenagers in the basement of St. Petri Norwegian Lutheran Church, complete with regular warnings of what "dancing might lead to." Unlike Marty's finery, my clothes were fashioned by my great-aunt Margretha, based on Simplicity patterns and fabric from one of the dry-goods stores in town.

Our social mores varied also. We were not a hugging-kissing family, though no family could have felt a stronger bond. Our Norwegian heritage taught us not to show emotion ("We don't go for that kind of show," Great-aunt Margretha sniffed) but we learned to be strong and stoic. The three Lutheran churches that anchored Story City also sent the message that girls did not swear, party with strong drink, or wear shorts downtown. Those who dared to smoke were headed for a life of sin, whereas Marty could hold a silver cigarette holder like Bette Davis.

Marty and I had met at college through our sorority after we both transferred from Iowa State College

at Ames. When she asked me to be her roommate, I was ecstatic and, truthfully, a bit shocked that she had chosen me. But running off to New York City together? When I told my parents, they were dumbfounded. That surprised me since they had always encouraged us to travel, and Katherine had even spent two summers working at Yellowstone while she was in high school. But talk about questions—they had *lots* of them! Where would the money come from? Where would we live? Didn't we know there was a *war* going on? As the support-the-war posters constantly reminded us: *Use It Up, Wear It Out; Make and Mend; Save Scrap for Victory!* In the spring of 1945, losses were escalating in the Pacific and submarines were still cruising the Atlantic coast. To my parents, wartime meant sacrifice, not frivolous escapades.

"I can do it on my own," I assured my father. "I have enough money."

But did I, really? Marty's idea of cashing in on empty soda bottles, at a nickel each, hadn't even begun to cover the $40 round-trip train ticket. During final exams, there had been bottles everywhere in the Kappa house, but we did have studying to do, so the collecting had been short-lived.

Marty's backup plan was simple: We'd use our savings. On that point, she didn't have any worries. The previous summer she had worked at a defense plant, wearing a special protective uniform to make tracer bullets. "I made sixty-four cents an hour because it was so dangerous," she had announced proudly, and she still had savings from another job, at Central Bank.

My job, playing cello with the Tri-City Symphony in Davenport on an as-needed basis, wasn't nearly as dangerous—unless you counted flirting with those cute musicians from Chicago—and it wasn't nearly as lucrative, though it paid well. Ultimately, it was my job at Towner's dress shop and an Iowa heat wave that had saved the day. On commission, I had sold swimsuits faster than tickets to a Humphrey Bogart movie. Everyone wanted to look like Rita Hayworth—with the barest midriff possible—so the two-piece suits practically sold themselves!

Still, after the train ticket, I'd have only $30. And as my parents argued, "You may have the money, but where will you live?"

Finding a place in New York City seemed an insurmountable obstacle from the rumors we heard. One of the preflight guys at Iowa U. warned us that leasing a furnished apartment was impossible. His father,

a journalist for the *New York Times,* had to share one room with three other writers. They'd used a plywood board across the tub in the bathroom to create a desk for typewriters and a cushion on the toilet turned the "throne" into a chair.

Our prospects looked dim.

But on May 18, just as an Iowa City summer filled with German classes and swims in the old quarry loomed large—and just five days before our self-imposed deadline for giving up our New York City dreams—a postcard arrived from a Kappa sister, Mickey Shuttleworth. She had promised to look around at the Manhattan apartment building where she lived with her family. Her penny postcard read:

106 Morningside Drive, N. Y.

Dear Marge,

I await with apprehension your decision about a room. Just heard about someone who wants two girls—but it doesn't sound too hot. I'm still recovering from two shocks, "A" in Phil. And (this will stun you) an "A" in Music Apprec.!!!!!!!!! Making a 3.8. Life is too good to me!

Love, Mick

Two girls? I ran up the stairs, shouting for Marty. What could be safer than living in the same apartment building as Mickey's parents? We rushed to get our folks' approval, cancel summer school, collect our war ration stamps for meat and sugar, and purchase round-trip coach tickets for the Union Pacific train. Most trains were already full, and servicemen got top priority, but in less than two weeks, we were at the Des Moines station, with our families in tow.

My heart raced when I heard the train whistle. I had never been on a train before, never been far from Iowa, but I was ready. Katherine had advised me always to keep a dollar hidden in my bra, so I had. My mother handed me a box of freshly baked kringla, my favorite Norwegian sweet bread. And Philip, my fourteen-year-old brother, pressed a five-dollar bill into my hand. I was flabbergasted. He must have mowed lawns all spring for that!

I'll never forget how my father's blue eyes misted when he handed me my suitcase on the steps of the rumbling train that would speed me away to a menacing city far from home.

I thought of him as I tried to write a letter home. The theater schedule had been tacked near the telephone. It included Fredric March in *A Bell for Adano*,

Margaret Sullavan in *Voice of the Turtle*, and Laurette Taylor in *The Glass Menagerie*. My father would have been thrilled. His passion was to act in plays, and he could recite Edgar Allan Poe like Lionel Barrymore. I didn't have the heart to tell him in a letter what he was missing.

106 Morningside Dr.

Dear Family,

Monday can't come soon enough! We're on pins and needles every second about that job *possibility*!! Can you blame us? This will surprise you—the first thing I saw at the Shuttleworths' apartment was a cello! Mrs. Shuttleworth had been a cellist and said I could practice anytime. Mr. Koelbel will be relieved—he was worried I'd be out of practice for the fall concert. The Shuttleworths' apartment on the top floor has a spectacular view of Morningside Park, and it's very homey with books everywhere. Mickey's father is very impressive—he's on the City College faculty. No wonder she's won so many honors—she has a job here for Psychology Corp. and is so busy we scarcely see her. Her roommate is Abby, another Kappa sister, which makes seven

of us in New York! It's hotter than heck here. Mrs. Shuttleworth makes *delicious* iced lemonade by stirring in whipped egg whites—try it, it's wonderful. The girls from Long Island were here for the weekend. There's not one dull moment when they're around.

Love, Marjorie

Never a dull moment. Our Russian neighbor, on the way to the elevator, shook a disapproving finger at us. Could it have been last night's party? In what language could we apologize? Joannie threw her hand over her heart, Marty whispered, "Sorry," Anita said, "*Excusez-moi,*" Sheila crossed herself with a mea culpa, and I prayed we wouldn't be tossed out.

Fortunately we were dressed to the nines, as if we were heading for Riverside Church to hear Reverend Fosdick. Instead, the five of us trooped over to the library at Columbia U. and sat on the steps. The plan was to feed the pigeons our last box of crackers—as if it were our life's mission—in hopes of meeting midshipmen.

The girls were gorgeous, with golden tans from the beach, while Marty and I looked like shut-ins from a

sanitarium. They talked a blue streak about the Broadway stars they'd seen at Sardi's, their discount clothes deals, and Joannie's boyfriend. Anita rattled on about weekends at "our" pied-à-terre. I glanced at Marty— what was that? When she pulled a long face, I knew. Good grief! *Our* apartment!

So there we were, baking in the sun, waiting endlessly for lonely midshipmen to stop by. We didn't see a single one. Should have known. Guys don't hang around libraries on the weekend.

Chapter Three

The bespectacled superintendent stood by his desk; the secretary's chair was vacant.

"There is a job opening for you young ladies," he said, staring at a space over our heads.

Ohmygosh!

"Due to the war there's a shortage of young men— and we need pages," he continued.

A page? The sudden image of that page "calling Philip Morris" with the daffy red pillbox on his head came to mind.

I had to ask, "What does a page do *here*?"

"They deliver packages to the repair and shipping department for the salesmen. It's an important service in the store."

"What would the salary be?" Marty asked immediately.

Marty!

"Twenty dollars a week."

Whoa! I didn't dare look at Marty—how could we live on that? We had both anticipated that any job at Lord & Taylor or Tiffany would pay well. *Especially* Tiffany.

Sensing our concern, he added, "Our young men are from eastern colleges. Sidney Greenstreet's son was one of our last pages." He left little doubt about living more on the honor than on the money—easy to do if your father was a movie star.

He continued, "Tiffany's has never employed ladies on the sales floor before—you'll be the first. Would you be interested in the position?"

We answered "Yes" in unison. He met our eyes for the first time, and there was a hint of a smile.

"Well, then, we'll sign a few papers. My name is Mr. Wilson." He invited us to sit across from him. His polished mahogany desk was fastidiously furnished with engraved leather and silver accessories, and a photo of a lady in a bronze and abalone frame.

In my excitement I sat down and bumped my foot against the chair leg. My blistered heel sent up shock

waves. I bit my tongue to stifle a cry and tried to force a smile. From the corner of my eye, I noticed Marty scrutinizing the papers, not making a move to find her fountain pen. What was she waiting for? Would she try to negotiate the salary? I fidgeted while the superintendent cleared his throat.

I was so relieved when Marty finally reached in her purse for her pen that I quickly opened mine—but it was upside down. Lipstick, bobby pins, mirror, comb, fountain pen, coin purse, Juicy Fruit gum, Tootsie Roll wrappers, and two loose nickels clattered to the floor. Marty shot me a look, but helped to scoop up my stuff. I was after the money, which had rolled out of sight. Calmly I bent down on my hands and knees, inched my hand as far as possible under the desk, found one nickel, reached for it, but gave up on the other one. My subway nickel was next to Mr. Wilson's shiny black shoes. When I tried to get up gracefully, I banged my head on the ledge of the desk, and shrieked, "Oops!" I sank back in my chair, frozen with shame. All my efforts to acquire proper poise with a swagger of confidence had vanished. I figured I'd better reacquaint myself with that humble position on the floor. With that salary, Marty and I would be scrubbing floors by the weekend. The well-meaning Mr. Wilson handed me his silver pen. I

smoothed my hair, tried to compose myself, thanked him, and signed the papers with an extra flourish.

"Next, I'll show you the employees' entrance and then your locker room," he said, glancing at the secretary's empty chair. I was relieved by her absence. Did she know about us? Had she left in a huff?

As he led us down a narrow hallway, I admired the superintendent's meticulous razor-sharp-pleated trousers and Windsor-knot tie, and the way each hair was combed in a perfect row across the top of his head. Still, it was disconcerting the way he avoided our eyes and seemed to speak to a ghost over our heads. But who was I to be picky?

Marty and I trooped behind him like Camp Fire girls on a field trip, startling employees along the way. Mr. Wilson led us past closed doors and hallways to an enclosure by the exit door. He introduced us to a small, uniformed man sitting at a counter.

"This is the gentleman who will clock you in each day," he said, handing him a slip of paper. "And this is the employees' entrance door from Fifty-seventh Street." He opened the door as a gust of hot air rushed in. When he closed it, he reached for his monogrammed handkerchief and wiped his brow.

"It's a scorcher today," Mr. Wilson commented as he led us back to a nearby bank of elevators. "We're

fortunate to have central air-conditioning—the first store in the city. The old Tiffany store was twenty blocks down the avenue, but our new building has all the modern innovations." I could sense his pride. The showplace on Fifth Avenue.

"These elevators are only for employees," he emphasized.

I had goose bumps when he said *only for employees*. This behind-the-scenes tour reminded me of being backstage before a concert. We had to be the luckiest girls in town to be part of the Tiffany family and watch the curtain open to the toniest display of jewelry in the world. As I daydreamed about our newly acquired status, Mr. Wilson was patiently waiting by the elevator.

The elevator operator, a ruddy-faced, rotund man, did a double take when we entered, the surprise on his face pretty obvious. When we reached the right floor, he cautioned, "Watch your step now, lydies," and rolled his blue eyes. I giggled.

My giggle came to an abrupt halt when the superintendent led us to the locker room and opened the door. There was the secretary, sitting on a bench in front of a row of gray metal lockers. She stood up, all but snapping to attention.

"I have the uniforms here," she said to Mr. Wilson, pointing to the box on the floor.

"Thank you, I'm sure they'll be the right kind." To us he said, "I'll see you later in my office," and was gone.

We're going to wear *uniforms?* Brass buttons, epaulets, and braid? Marty's eyebrows shot up.

"I hope they'll fit," the secretary said, reaching for the box. When she folded back the tissue paper, she lifted up two of the most perfect day dresses that I had ever seen—shirtwaist style in an aqua-blue silk jersey.

I didn't know what to say, I was so in awe.

"These are *elegant!*" Marty cried. "May we try them on?"

The secretary motioned us toward a full-length mirror. "Of course. That's why we're here—I need to see if they'll fit."

I ran my hand over the silky material. "I can't wait to try it on." I'd *make* mine fit. But did I feel guilty. How Marty and I had mocked the poor secretary last weekend: her 1930s hairdo, her disapproving frown, and her quivering double chin. My face was hot with shame. How could we have been so mean?

Marty modeled her dress in front of the mirror. "It fits perfectly."

"And mine," I said, cinching my belt into the last notch. "We're going to look *so* smooth!"

"They're in very good taste." The secretary seemed pleased. "You'll be the only young ladies on the sales floor, you know."

She looked at me with saucer eyes. I turned red, remembering my ill-timed "We can sell jewelry" remark. *Good heavens.* "I almost forgot," she added, "the superintendent will have black leather shoulder bags for you tomorrow—you'll need them for deliveries. But now you have an appointment at the nurse's office. Keep the dresses on for the moment—I want her to see them."

"A nurse?" Marty looked at me in surprise.

"Yes—Mrs. Ross, our nurse." She led us down the hall.

As we stepped into the nurse's office, Mrs. Ross opened her arms. "I've been waiting to meet you—it's time we had young girls for pages." With her soft hazel eyes and dark hair parted in the middle, she reminded me of my mother.

"Are these the *uniforms*?" she asked. "The color is fabulous—where in the world did you find them?"

"At Bonwit's." The secretary was beaming. "When the salesgirl brought these out, I knew they'd be perfect."

Marty and I stared at each other. *Bonwit Teller*? That exclusive store?

"Well, I must say," the nurse said, pointing to the scale, "you two could be Powers models. Won't you brighten up that main floor!"

Her enthusiastic comments bowled me over. Our height, our hairdos, our complexions, our "Midwest rosy cheeks." She was even thrilled with my *teeth*. "No fillings?" she said, after checking my mouth. "You'll never see that out here—it must be that good Iowa water." After the hysterical episode in Mr. Wilson's office, her praise sang to me like a Schubert melody. "But, one more thing. Didn't I notice you limping?" she asked me. "Is it a sore blister?"

I nodded, and she reached for a bandage, "Here now, slip off that shoe a minute." She capably and carefully wrapped my foot. I blinked, my eyes wet— she was so much like my mother. Horrified that I might cry, I stammered, "I don't know how I could've taken another step. It's so—" and I couldn't say another word. She patted me on the shoulder. "It's going to feel better in no time. But you do need to take care of it."

She sat down at a small desk to fill out a form, and then turned. "So have you girls had a tour of the upper floors?"

"Not yet," the secretary answered for us.

"Well then, you're in for a treat. The second floor will take your breath away—all in sterling silver—with candelabras, I swear, as tall as you are." Mrs. Ross gestured. "But now the third floor—with the china and crystal—that's my favorite . . . just wait till you meet Mr. T.C. on that floor—"

"The important thing," the secretary interrupted, moving toward the door, "will be for them to see the repair and shipping departments."

"And the secret—?" Mrs. Ross started to say.

"No," the secretary cut her off sharply. "Oh, no." And with that, we were ushered out the door.

On the way home, we flew. There were postcards to send, the Shuttleworths to tell, and the Long Island girls to call. That night, Marty and I replayed every scene from the day like frames in a home movie. The most mind-boggling detail was—"the secret" *what*?

<div align="right">106 Morningside Dr.</div>

Dear Family,

 Thrilled to pieces! We have the job at *Tiffany's!!!* Can you believe it? We'll be the first girls they've ever hired to be pages. Biggest surprise—the secretary bought us lovely Tiffany

blue dresses for uniforms from a *very* expensive store—Marty and I feel like models!

At the Shuttleworths', we heard about the terrible battle over Okinawa on the radio—it's headlines in the papers here. I'll bet Aunt Olive and Uncle Peter are worried to death about the boys. Please give them my love. More later.

Love, Marjorie

P.S. We'll be paid every week—you don't have to worry anymore!

Worry? With our friends screaming with envy, Mrs. Shuttleworth's eyes as big as dinner plates, and our parents thinking we'd landed the ritziest jobs in Manhattan, you'd think we were on easy street. Good heavens—how will we exist on that next-to-nothing salary?

The rent would swallow most of our pay, and we'd conveniently forgotten about an electric bill. Then Mrs. Shuttleworth reminded us to save for the elevator operator's Xmas fund! *Ohmygosh.*

Marty drummed her pencil on the desk. "Personally, I could live on Nestlé's chocolate milk."

"Or we could try baking our own bread—it only takes flour and water," I offered.

"Make *bread*? Is that when you dip your elbow in the water to check the temperature? For heaven's sake! It's hot enough in here without turning on the oven!"

"What about that Wheaties and celery diet?" I suddenly remembered.

"Good land!" Marty said. She sharpened her pencil, and began adding up the numbers. We'd agreed before we left for New York that we'd never write home for money. We'd make do.

"Don't forget the Broadway shows," I reminded her.

"Are you crazy? The midshipmen get theater passes!"

THE BUDGET—RENT AND ELECTRICITY— $65.00 A MONTH

Daily

1. Two nickels for subway (daily)

2. Sandwich and drink at the Automat: 15 cents

3. Nestlé's chocolate milk & toast (deli egg bread)— breakfast & dinner: 9 cents

4. Penny postcards—no 3-cent stamps

5. Weekly elevator operator's Christmas Fund— 25 cents

DISCRETIONARY FUND (IF THERE IS ONE!)

Select one for the week:

Oxydol laundry soap, Woodbury hand soap, bronze stocking stick, Pond's hand cream, Jergen's lotion, Dubarry nail polish, Kreml shampoo, Max Factor powder, Colgate toothpaste, Tangee lipstick, Coca-Cola, Lucky Strike cigarettes, Schrafft sundae, drink at Sardi's

Tickets: Staten Island Ferry (5 cents); Empire State Tower ($1.10); Lewissohn concerts (25 cents); Paramount Theatre; Radio City Music Hall

A girl can dream, can't she?

Chapter Four

It was morning. Sunlight filtered in with the smell of burnt toast. Hurriedly, I stirred my Nestlé's as we talked nonstop, fueled by adrenaline and chocolate. I brushed my hair and filed my nails as we took turns with our lipstick in front of the tiny mirror above our dresser. I tried to think of cover girl Jinx Falkenburg's fashion model tips, but only remembered one: Lift your chin above the horizon. I could practice that on the way to the subway.

Joining the working crowd and rushing to the subway station was exciting, though not as romantic as the leisurely Riverside bus ride along the tree-lined parkway with its luxury penthouses and terraces. But there was still a thrill to catching the train, hurtling

like a rocket down the tracks, and making the curves as if we were on a roller coaster.

We emerged with a throng of people, and made our way to Fifty-seventh Street and Fifth Avenue. Near the employees' entrance I stopped dead. On the door of the building next to Tiffany's was a discreet sign: MAINBOCHER.

"Ohmygosh, isn't that—"

Marty moved closer to look. "It is!"

Mainbocher was a leading fashion designer, and *the* designer for the Duchess of Windsor—or her couturier, as *Vogue* would have it. Anyone old enough to turn a page in *Life* magazine knew the duchess's style: the fitted suit with the matching off-the-face hat, the satiny tea gown with the beaded bag, the classic tailored dress with the thin-strapped heels. From her filmy lingerie to her lush sable coat, Wallis Simpson wore the famed Mainbocher label.

I had been surprised when I found out that Main Rousseau Bocher was an American from Chicago, and that he had moved his "house of couture" from France to New York just before the war broke out in Europe, but I was even more impressed with his contribution to the war effort. He'd designed the smart, tailored suits for the Women Accepted for Voluntary Emergency

Service (WAVES), and their recruitment brochures had even touted his work with the slogan "It's a proud moment when you first step out in brand-new Navy blues! . . . Designed by the famous stylist *Mainbocher* to flatter every figure and to make you look—and feel—your best!"

Now here we were, but unlike Tiffany or the many exclusive stores at which we'd filled out applications, Mainbocher certainly wasn't a place where you were invited in to browse—either in person or through big streetside windows. There were no windows whatsoever, and I wasn't sure if the door was even unlocked.

Marty took it in stride, but I stopped to stare. In sixth grade my girlfriends and I were infatuated by the dapper, eligible Prince of Wales. When we heard his suave British voice over a worldwide broadcast announce that he was throwing over the crown of England for "the woman I love," we were "besotted" (we dropped that word *whenever* we could as we imagined that being besotted by a prince put us into a far different league than the boy passing us notes across the aisle). We kept the flame flickering even after he married Wallis Simpson, and followed their exotic life all the way to the Bahamas, their safe haven during the war.

. . .

After we clocked in, the elevator operator smiled and took us to the floor of the locker room. The room was narrow with a row of gray metal lockers, a green bench, and a floor-length mirror at the far end. We changed into our Bonwit's dresses, preening by the mirror. I felt like a movie star and Marty looked every inch the runway goddess—never mind that one size smaller would have been perfect. At Mr. Wilson's office, I smiled at the secretary, who waited for the superintendent's approval. Did he like our new uniforms? He didn't say—I was disappointed, especially for the secretary, to whom we were so grateful—instead, he gave us each a sleek black shoulder bag with the smell of fine leather.

"You'll need these for delivering the packages," he said, aiming his instructions at the rear wall (I no longer looked over my shoulder). "The important thing for the page is to recognize the signal. When a salesman needs a delivery, he'll rap his ring sharply on the counter—that's your sign."

Already I had my first question. "Will the rap be loud enough to hear across the floor?"

"Yes, of course. Each salesman wears a diamond

ring, and as we say—a diamond sings against glass." I loved the new expression and couldn't wait to hear our first rap, imagining how it would sound. I had only been in one other jewelry store in my life, in Story City, and the jeweler, Magne Idse, sold far more watches than diamonds—and he certainly didn't wear a diamond ring!

"What do we say to the salesman?" Marty wanted to know.

"For now, just address him as 'sir.' As soon as you can, learn the salesman's name and number. We're as discreet as possible at Tiffany," he said.

When Mr. Wilson ushered us to the main floor, he indicated the place for us to stand. Our "station" was against the paneled wall, between the mirrors that were framed in marble.

"If you need me, I'll be in the far corner," he said, pointing to a spot near the cashier's window, maybe twenty steps away. Then he was gone.

Marty and I stood as straight as two beanpoles, gazing at the nearest counters. To our left was the watch counter, near the Fifth Avenue entrance, where Tiffany offered its customers exactly one brand—the legendary Patek Philippe, men's and women's, with or without diamonds. I had never heard of this brand, and was surprised Tiffany didn't carry Elgin.

To our right was the stationery counter, with chairs where customers could sit as they selected their engraved cards and stationery. Directly in front, two salesmen handled glittering ladies' accessories and evening bags. They welcomed us with a nod and a smile.

Marty whispered, "They look like Mutt and Jeff." The likeness, one tall with bushy hair, the other small and bald, was so remarkable, I began to giggle. Mr. Wilson shot us a dour look, and I clamped my mouth shut.

Looking across the room, I nudged Marty and whispered.

"The Tiffany Diamond."

Dominating the first floor was the famous Tiffany Diamond, set in a glass case behind the diamond counter. It was so dazzling, I blinked. Mr. Wilson had explained, "People come from as far as China to view the diamond. It has a hundred and twenty-eight carats, the largest canary diamond in the world." We wondered what it was worth, but Marty didn't ask.

I watched for the first rush of customers, but it was only a trickle: an elderly lady headed for the customers' elevator, a stooped man with a cane approached the watch counter, and a navy commander, accompanied by a redhead wearing a John Frederic's hat with a half-

veil, stopped by the stationery. The nurse had warned us, "You won't find the store busy in the summer—the Four Hundred are vacationing at their homes near the ocean."

The Four Hundred? I had no idea what or who she was talking about, so I had asked Mrs. Shuttleworth, and now I was prepared. If someone looked like they owned half of Manhattan *and* had a box at the opera, and happened to mention an invitation to the Astors', they were most likely one of the Four Hundred. Mrs. Shuttleworth had another, shorter definition: The Old Money of New York.

When a sharp, percussive *ping* rang out, I was startled. Was *that* the signal? It came from the watch counter, and Marty took off. I carefully watched the routine. A white-haired salesman with glasses chatted with his customer, and then handed Marty a package with instructions. She placed it in her shoulder bag and sailed off, poised and self-assured. Easy. I felt important waiting for my turn.

I didn't wait long. The next "rap" was barely perceptible. I couldn't pinpoint the location, but knew it was from the opposite side of the floor.

Confidently, I marched past the cashier with the bushy eyebrows, who smiled, and past the navy commander with his stylish friend at the stationery counter. I noticed they were looking at wedding invitations—how romantic. I turned the corner at the next aisle, looking for the salesman who had rapped. As I passed several salesmen, I felt their eyes boring a hole in my back. None of them gave any indication I was needed.

My heart pounded as I altered my course, trying to look as if I knew where I was going. *I'd better keep moving—I can't stand still looking like a nitwit.*

I kept my chin in the air, not daring to look at the gleaming array of jewelry or the salesmen. I clenched my teeth. Where was Mr. Wilson, for crying out loud, now that I needed him? Couldn't this diamond rapper wave, whistle, or holler? I had sailed past most of the counters and found myself by the Fifty-seventh Street revolving door—a dead end. The doorman was watching, studying my circuitous route. I hyperventilated and clutched the black bag for support. I didn't know where to turn next—maybe out the door—when I caught the aroma of an exotic perfume radiating from a stunning customer, a brunette engrossed in a conversation with a salesman.

I took a chance.

"May I help you?" I squeaked, my voice in an upper register.

The salesman looked up. "Oh, yes, Miss," he said, finally noticing me. "Please take this bracelet to the repair room."

Oh, was he good-looking!

While he wrapped the bracelet, I tried to steady my heartbeat. I was elated—my first errand a success. I noticed he was younger than the others, with wavy dark hair and a devastating smile.

He handed me the package, which had the number 15 written on top. "Our customer will be taking the bracelet with her—we'll wait for the repair."

"Yes, sir." I almost bowed.

He smiled in a way that made me blush. But his beaming expression was for the glamorous brunette. She looked like a fashion model with her ostrich leather heels, straight out of *Vogue*.

As I turned to leave, confident and poised, I proceeded in the nonharried, composed saunter of a runway model. I headed for the service exit, smiling at the cashier as I passed. *Look at me now.*

The second I left the main floor, I tore down the hall to the employees' elevator.

"The repair department, please," I said breathlessly.

It was the same ruddy-faced operator we'd met before. I felt sorry for him, standing in an elevator all day with swollen ankles spilling over the rims of his shoes. When we reached the second floor, I thanked him. "Yes, Miss," he said, nodding.

Along the corridor, a clerk was waiting at a counter in front of an enclosed room. Through a bank of windows, I could see men hunched over desks, peering through loupes at their work. Mr. Wilson had described them: "They're master craftsmen in the repair department—and spend days, sometimes weeks on one item of jewelry."

"Sir," I said to the clerk, "this is for number fifteen. The customer is waiting for the repair."

Please, hurry, I wanted to add.

He opened the package. "It's only a broken clasp—it won't take long," he assured me, and left for the repair room inside.

I was relieved. I'd be back in minutes to prove to the salesman (was it Cary Grant or Gregory Peck that he resembled?) how efficient I could be. While I waited, I watched the men absorbed in their meticulous work, fascinated by their array of delicate tools. Then I followed the second hand on the large clock across the room. As I began to fidget, I counted the number of

squares on the parquet floor. What was taking so long? I feared the salesman would think I'd left the building.

Suddenly there was my man, picking up the package. He closed the door and handed it to me. I thanked him and flew down the corridor for the same elevator.

"Main floor?" the friendly operator asked.

"Yes, *please.*" I caught my breath.

I had an inspiration.

"Would you happen to know this salesman's name— he's number fifteen?"

"Fifteen? Dat's Mistah Hoydman."

"Hoydman?"

"Dat's right."

Wonderful. It wouldn't take long to master their names—I could just ask that operator. "Thank you so *much,*" I said, feeling I had conquered a page's job.

Back on the main floor, I approached the salesman, who was still chatting with the lovely brunette with the flirtatious giggle. They hadn't missed me at all.

"Here's the package, Mr. Hoydman," I spoke clearly.

He stared at me, frowning. He murmured, "Thank you," and turned abruptly to Miss Ostrich Heels. As he rewrapped the bracelet for her, he motioned me to leave. He had been so curt; something was wrong. Definitely wrong. Had I made them wait too long?

When I heard her leather heels *clickity-clack* out of the Fifty-seventh Street exit, the saleman rapped again. I hurried back to his counter.

"Yes, Mr. Hoydman?" I said as cheerfully as possible.

His narrowing eyes would have cracked an iceberg, and his words were daggers. "What. Is. Your. Name. Miss?"

"Miss Jacobson," I said as my voice trailed away.

"Miss Jacobson, I understand you're from Iowa. How did you pronounce 'bird' over there?"

Huh? "Bird."

"And herd?"

"*Herd.*" Ohmygosh. I knew where this was going.

"Good," he said sharply. "My last name is Herdman—Mr. Herdman!"

My face burned! *Nice going, Miss Iowa Hick.* And this was only my first day.

106 Morningside Dr.

Dear Family,

I just received your letter—can't believe that Tiffany's called you long distance, Dad! What did you say—what did *they* say? What that must have cost! I'll bet the Holm sisters at the phone company will have it spread all over town!

The news here is the upcoming parade for General Eisenhower. We'll see him in person! Mayor La Guardia is calling a holiday—they expect millions to turn out. Mrs. Shuttleworth told us we could find seats on the steps of the NYC Public Library. We're leaving early tomorrow. Everything is great here.

More later.

Love, Marjorie

P.S. Remember that radio program that's so funny—the way they say "goils" for girls? Guess what—some people really do talk like that!

If I'd only known how to recognize a Bronx accent! Gnawing on a piece of dry toast, I sat staring through our window at the bare brick wall. Marty was trying to cheer me up, saying, "Old Mr. Herdman looks like a sourpuss to me!" She stretched out on the studio couch to light a cigarette when the phone rang. I answered.

Me: Hello—Oh, hi, Sheila . . . (Marty looked up)

Sheila: Hey—seen any midshipmen yet?

Me: Not yet—we've been too busy working. Are you going to the parade?

Sheila: That's why we're calling. They're expecting

millions—with that crowd we'd never get home. How 'bout spending the night?

I covered the mouthpiece to tell Marty—she shrugged.

Me: Sure, but bring your own drinks—just in case we're out. (Marty rolled her eyes.)

Sheila: How do you like work—and that snazzy neighborhood?

Me: We love it—and guess what? Mainbocher is next to Tiffany's.

Sheila: Hold on a minute. How'd you say that? Anita's laughing— Lordy—wait a second—*Ohmygod, I can't stop laughing.* Can you hear her?

Me: Oh—okay—right . . . *right.* That does sound better—tell her thanks.

I signed off and hung up the phone.

"So?" Marty jumped up, crushing her cigarette.

"Well"—I started to laugh—"it's pronounced '*Man-bou-shay.*' not 'Main-bockers.'"

"Swell. Remind me to tell them we're not pages, either—we're *couriers,* m'dear!

Chapter Five

Marty hung up the telephone, snapping her fingers as she wriggled her hips.

"Are you ready for this? We're going nightclubbing—the Byoirs are taking us out . . . *tonight*!"

"How in the—"

"It's true! We're meeting them at their Park Avenue apartment!" she sang.

"Holy Toledo!" I leaned against the refrigerator, feeling light-headed. Park Avenue, nightclubs, celebrities, photographers!

We already considered ourselves intimately familiar with life behind the velvet drapes, thanks to *Life* magazine, which delivered almost as much news about "Café society" as it did about the war. And who didn't

listen to Walter Winchell's latest Manhattan society gossip on the radio? Even Pepsi ads were set in the booths of El Morocco. Now those black-and-white photos and radio recordings would be replaced with the real thing. We would see for ourselves what really happened in Café society.

Within minutes, our apartment had the aroma of Bonwit's cosmetic counter. The bathroom clouded over as we shampooed with Kreml (*"Glamour-bathe your hair in Kreml,"* the ads in *Life* urged), lotioned with Jergens, and powdered with Max Factor.

In went the bobby pins to make sure we had plenty of curls in our straight hair. Out came the ironing board, because my black short-sleeved linen blouse and matching skirt were fresh off the clothesline in the basement. As I worked through every wrinkle, using a damp tea towel under the iron to provide the steam, Marty and I kept up a steady banter.

I was so lost in anticipation, I almost scorched my black blouse with the iron as I yelled to Marty, "Hey, remember that debutante, Brenda Frazier—all those snazzy pictures of her in the Cub Room at the Stork Club?"

"And wearing that slinky, strapless, black taffeta gown—who can forget?" She laughed.

"Well, my outfit will be a far cry from that." I looked like a waif from the orphan train in my simple black blouse and skirt.

The minute the New York apartment was confirmed I had known that I had to do something to update my wardrobe—even if I could only afford one new piece.

At Towner's, the campus shop where I worked, I was always on the lookout for double markdowns, and that's how I got the classic short-sleeved black crepe dress. Fitted at the waist, with a narrow belt and a pencil skirt, it was sleek and simple, appropriate for almost any occasion—and with my employee discount on top of the markdowns, the price was right!

But nothing in my suitcase rivaled my Jantzen halter neck "date dress" that I'd been wearing since high school. Oh, that dress! Fine, light blue-and-white-striped cotton fell from a fitted waist into a huge full skirt that made me want to twirl around—it was the flashiest dress that I'd ever owned.

But I couldn't wear my sundress *everywhere*, and the contents of the single suitcase I had brought to New York were unremarkable. I'd tossed in my summer favorites: Bermuda shorts, teal culottes, and my one-

piece Esther Williams–style bathing suit, a couple of white cotton blouses, old sandals, and three swing skirts—dirndl, print, and accordion pleated. (The cello had a fatal effect on my fashion life: always full skirts, nails filed to the nub, and calluses.)

I wore my best outfit on the train: a black three-piece linen-like suit, sling-back pumps, and my all-time favorite, a broad-brimmed cartwheel hat. Everything was black (*what was I thinking?*), and I carried my white gloves and a herring-bone coat, which doubled as a raincoat, with a blue scarf stashed in the pocket. I must say I felt very Harpers Bazaar-ish when that train came down the tracks.

When Marty opened her suitcase, I jumped up. "Ooooh—that navy blue shantung!" That wasn't all; she had an aqua silk jersey, a pink sharkskin, and white linen to die for. Four *new* dresses, no doubt from Younkers' special floor where you didn't dare look at the price. Marty, the best-dressed Kappa, could wear clothes like a *Vogue* model—the pencil skirts, chic fabrics, and always the classic, elegant style.

As for Marty, her only problem was trying to decide which dress to wear. She finally settled on the aqua silk jersey with thin black vertical stripes, kimono sleeves, and mother-of-pearl buttons.

At such moments, I didn't feel envy, just good fortune at having such a generous and outgoing friend. We would have a good time no matter what we were wearing, and my understated outfit would be a nice counterpoint to Marty's more glamorous style.

Still, we were nervous about our choices. At the last moment we decided to ask Mrs. Shuttleworth for her opinion.

"You girls look darling—and don't you worry," she said, wiping her floury hands on an apron, "you look better than those debutantes flouncing around in formals who've forgotten there's a war going on." She was right. The patriotic thing to do was to make do with what we already had in our closets. Resources were depleted, and production of servicemen's uniforms was one of the highest priorities.

Just before we walked out the door, we added the final touch: a spritz of Evening in Paris on our hair.

When Marty and I caught sight of the blue-striped canopy in front of the Byoirs' Park Avenue apartment building, we nudged each other excitedly. The brass-buttoned doorman led us through the lobby, and a white-gloved elevator operator took us to the top floor in the paneled elevator. When we emerged from the

elevator, Carl Byoir greeted us warmly and brought us into the foyer to meet his wife.

"I've heard *so* much about you," she exclaimed, reaching out to hold our hands.

"Carl's right—you *are* the prettiest girls in Iowa. I'll bet Tiffany's thrilled to have you!"

Her effusive welcome made my cheeks turn red. She was dazzling, from head to toe. Taller than Mr. Byoir, she had a model's figure. Her dress was a shimmering white lamé, and her brilliant necklace was so stunning, it was difficult not to stare. Even Marty was wide-eyed. Beyond their foyer, I caught a glimpse of French provincial furniture, ivory cushions, fresh flowers in crystal vases, and a door leading to an outdoor patio. What would it be like to cool off in the evening on a terrace, under the stars?

"Are we going to the Stork Club, dear?" Mrs. Byoir asked, reaching for her beaded bag.

"We'll see," he said with a sly smile. "The taxi's waiting."

The attentive doorman ushered us into the waiting cab. "Good evening, sir, have a pleasant night." I felt giddy as we slid into our seats. My first taxi ride.

Mr. Byoir leaned forward to the driver. "The Stork Club, please." I wanted to shriek with glee. Marty

and I knew the Stork Club's rich history and famous guests, having stared at hundreds of photographs of movie stars and politicians and rich young socialites. Just ask us about the club's signature perfume or The Snowball—ice cream rolled in shredded coconut, then drizzled with chocolate sauce! *Everyone* knew about the Stork Club.

Now we were sitting in the middle of it all, craning our necks in search of someone famous, and Mr. Byoir decided he needed to call Iowa. One of the waiters, dressed as they all were in a white double-breasted jacket, was asked to bring a telephone to our table, just like in the movies, and soon we had one, a long cord trailing across the room. Mr. Byoir wanted to call "Stub" Stewart, his old college friend in Des Moines, but Stub wasn't at home, and that was just fine with Marty and me. We stayed for only one glass of champagne, and then we were off.

"La Martinique, please," Mr. Byoir said to the driver.

We entered under a sparkling marquee, and were met at the door by the maître d' in a tuxedo.

"We have a special table for you this evening, Mr. Byoir," he said, leading the way. Following Mrs. Byoir's trail of perfume, I noticed couples in velvet-cushioned

booths, waiters carrying trays of tinkling glasses over their heads, and servicemen and their dates on the dance floor. It was the sound of the band and the sultry beat of "Begin the Beguine" that started my heart in the rhumba rhythm.

The maître d' led us to a table by the stage. Everybody was smiling: Marty, Mr. and Mrs. Byoir, and, most of all, the maître d', who bowed. Waiters suddenly appeared to seat us, fluffing napkins across our laps and pouring ice water. I was amazed by the attention. No wonder *Life* idolized Café society.

On the dance floor, an army general, weighted down with ribbons and medals, was sweating as he tried to rhumba with a matronly lady dangling her charm bracelet over his shoulder. She was wearing nylons— *black market* nylons. Obviously, it didn't hurt to know the big brass.

The smell of cigar smoke and Chanel No. 5 drifted to our table, when a waiter suddenly appeared. "A cocktail for you, Miss?"

Startled, I caught my breath. As nonchalantly as possible, I said, "A vodka daiquiri with a twist, please."

It paid to listen—and listen carefully. On our train trip from Iowa, Marty and I were playing cards in the club car when the bar opened and I overheard a lady

order that cocktail. "It's a ladies' drink," she had said. Not knowing a daiquiri from a dandelion, I thought I'd better write that one down.

Marty shot me a funny look and ordered a Manhattan. I smiled to myself, knowing that I'd surprised her. The Byoirs requested a bottle of champagne. When we were served, Mr. Byoir toasted our new job, "To Tiffany!"

How could you not love this high-society life? La Martinique was filled with high-ranking officers, women dressed to the nines, waiters at the elbow, and a twenty-five-piece band playing one hit song after another. When they began "Moonlight Serenade," I remembered the time I had danced to that Glenn Miller favorite, my hair damp against my date's shoulder, the rough feel of his air corps uniform, and the smell of my gardenia.

But I knew what my father would think of this decadent nightclub scene. If he'd caught sight of that general dancing the rhumba he'd never get over it! There were ration stamps to save, victory gardens to spade, and blood to donate for the soldiers. For a moment, I felt a pang of guilt, but as soon as the band swung into "S'Wonderful," I was as thrilled as a Sinatra bobbysoxer. My foot was tapping.

Mr. Byoir asked Marty to dance. I could see she was unsure, but did not want to decline.

Once on the floor, she was easily two inches taller than he, thanks to her high heels, but they were graceful dancing together. And Marty's dress stood out, even in this crowd.

Suddenly, they stopped dancing, pausing at a floorside table to chat with other guests. *Did Mr. Byoir know everybody in this city?*

And later, when the band started to play "Don't Get Around Much Anymore," Mrs. Byoir began to hum along. She turned to her husband and reached for his hand, and he winked at her. Can you still be romantic when you're that old? I felt tingly all over as I took another sip of my icy daiquiri.

Suddenly there was a spotlight on the stage and a drumroll. A man stepped out. "Ladies and gentleman, our master of ceremonies—Mr. Harry Richman!" The band struck up "On the Sunny Side of the Street" to a burst of applause and whistles.

"That's Harry's theme song," Mr. Byoir said. "He's the one who made it famous." Needless to say, he'd made most of those Jazz Age songs famous.

Harry Richman had dark, wavy hair and a deep tan. "A Florida tan," Mrs. Byoir whispered. "And you know

he's broken records as a transatlantic aviator—flying is his hobby." His hobby! As if being a Broadway star wasn't enough!

After a few jokes, he began introducing the celebrities in the audience. First, it was the general, the rhumba-inspired one, and then a popular Broadway star. As soon as the spotlight found her, she beamed, leaped up with a hand on her hip, and blew a kiss. Next, the spotlight hit our table. I jumped. Marty drew in her breath. Harry Richman approached and placed his hand on Mr. Byoir's shoulder.

"This gentleman was President Roosevelt's public relations expert. He created the Committee on Public Information and organized the Birthday Balls to fight infantile paralysis. We know the name he made famous—the March of Dimes. I present Mr. Carl Byoir!"

The audience broke into applause as Mr. Byoir stood up and a photographer rushed to our table. Marty and I stared at each other. So *that's* who he was. Now it made sense: the photographs with President Roosevelt, the picture of the gigantic birthday cake, the office on the top floor with his *name* on the building. I could scarcely wait to write home about it.

After the photographer left, Mr. Byoir was in a talkative mood. He and his wife had attended the dinner for

General Eisenhower at the Waldorf-Astoria. After Mrs. Byoir described the lavish five-course meal, he laughed. "We were only two of the sixteen hundred guests!"

When Marty asked Mr. Byoir about his work with President Roosevelt, he poured another glass of champagne and leaned forward.

"My most difficult assignment was to change the country's opinion about Russia. Roosevelt knew we needed Russia for an ally, but first it had to be acceptable. So I began first on college campuses"—he stopped to light a cigar—"and I planned debates for radio broadcasts. Finding professors to debate communism was never difficult—and the newspapers were only too glad to cooperate. Then—the cultural emphasis—music, ballet, and so forth."

How true. I thought of the touring Don Cossack Chorus, the Prokoviev recordings my sister and I had collected, and the sudden popularity of Shostakovich's Fifth Symphony. For my father it was a different story. When the newspaper mentioned "Papa Stalin," he'd slap the paper on the table and rant against the evils of communism. Some of this stuff I'd better *not* write home about.

When a waiter asked about a refill, I shook my head—my lips were numb. Harry Richman walked

over to join our table. Our table? I felt dizzy as the Byoirs greeted him like an old friend.

Mrs. Byoir introduced us. "These girls are from Iowa, where Carl went to school. And you'll never guess—they're working at Tiffany!"

"*Tiffany*, by God!" he said, looking up. "Let's drink to that! You know how long *I've* been working for them." They all laughed. All but me. Those were Mr. Byoir's words, the day we met. My smile faltered, realizing what he'd meant. One glance at Mrs. Byoir's priceless diamond necklace said it all. I felt like slinking under the table. What a laughingstock I must have been at my interview with President Moore. I polished off my daiquiri, feeling light-headed.

Before the evening was over, Mr. Byoir gave us prudent advice.

"Don't you girls believe everything you read or hear. You're smart enough to form your own opinions."

I've never forgotten those words. Advice my father already knew.

106 Morningside Dr.

Dear Family,
 We saw *General Eisenhower*! He rode down Fifth Avenue with his son in a convertible. And

the crowd—the paper said *4 million!* We were lucky—leaving early for the New York City Library, we found space on the top steps—some boys were perched on the lion statues. When the cavalcade of cars came down the street, General Eisenhower stood up and held his arms in a V for Victory sign. We went wild! We cheered so loud, I thought I'd go deaf. Confetti and paper streamed out of the windows like snow—the streets were knee-deep in litter all the way to City Hall.

That's not all. Remember Mr. Byoir—Marty's connection? The Byoirs took us to a ritzy nightclub and Harry Richman—that famous showman—introduced Mr. Byoir, spotlight and all. At last we found out what Mr. Byoir does. He was President Roosevelt's public relations expert. The Byoirs went to a dinner in honor of Eisenhower at the Waldorf-Astoria that cost *$18 a plate!*

Tell Katherine—Happy Birthday on the Fourth! I'm thrilled they're going to have a baby! How will you like being an uncle on New Year's Eve, Phil?

Well, that's the excitement here.

Love, Marjorie

And there was plenty of excitement! Marty was stirring her chocolate milk, still rehashing that night. "When I saw Mrs. Byoir's diamond necklace I couldn't believe it—like that incredible one we saw in the window!"

"Think what a fortune it must have cost," I added. "No wonder Mr. Byoir said he was *working* for Tiffany—it would take a lifetime. Honestly, Marty, when I think of that interview! You should have heard me that day—'He's working for youuuu—'" I sang in a falsetto.

"So we took him literally? I'll bet they thought it was cute—how terrible is that?" she said, finishing her drink—and almost choked as she started to laugh.

"But when you ordered that *vodka* daiquiri with a *twist*—that *was* funny!"

Funny? What was she talking about? I was thrilled to come up with that drink on the spur of the moment.

"It's a ladies' cocktail, in case you don't know—and I loved it," I said, a bit miffed.

"Okay." She was still laughing. "Okeydokey—just kind of a shock—as if you're a regular at the bar." And she laughed again.

"So the girls don't have to hear about *that*."

"Don't worry. But I'll tell you what they're going to hear. It's time they started chipping in on our electric bill."

"You're kidding! They think we're rolling in dough," I said, wiping away the toast crumbs. "They'll never understand—"

"Hey, if we were rolling in dough—we'd be at the Plaza in the Terrace Room wearing one of those black tulle dresses from Bonwit's and silver ankle straps from Delman's."

"Or Louis Philippe makeup from Saks," I chimed in.

"How about a gown with Anna Karenina–ish ruffles from Mainbocher!"

"And a Bergdorf turban—" I giggled.

"With a diamond clip in a fleur-de-lis design!" Marty said in a low husky voice. "Please—wrap it up in the little blue box!" She dissolved in giggles before she clapped her hand over her mouth and said, "And can you believe Mr. Byoir asked me to dance?"

"I know how you must have felt, but I certainly wouldn't mind dancing with someone that famous. But who were those people at the table where you stopped to talk? Were they friends of his?"

Marty smiled. "He didn't know them. They kept pointing to me as we were dancing, so he just went up

and said, 'Hi.' And this woman said, 'Did you get your dress at Henri Bendel?'"

"What a riot! Did you tell her it came from Des Moines?"

Marty started laughing. "I just told them someplace in the Midwest. I wasn't about to tell them that I made it myself."

I stared at her for a minute, shocked.

"You have to be kidding! You mean you sewed that dress—you did all those little button holes on that silky fabric? When did you learn to do that?"

"It was easy—I've made all of my clothes ever since the fourth grade!"

"Fourth grade? For crying out loud, Marty—you've never said a word. What other secrets are you keeping from me? The next thing you're going to tell me is that you knit your own sweaters."

She looked at me again. "I do."

I hardly knew what to say. "Those *sweaters*—that gorgeous pink cardigan, and the black-and-white tweed—are *handmade*? And I thought you were Younkers's best customer!"

"I was, really—that's where I bought my yarn and fabric. Younkers gave knitting lessons on Saturday mornings—so my sweaters only cost two dollars. With

round needles, I never had to watch what I was doing and I could knit away at the movies. . . . I figured I could have twice as many clothes if I made my own."

"Does anyone else know this?" I asked in awe.

She shook her head.

That Marty. *My best friend.*

"Well, if I could do that, I'd be telling the whole world!"

Chapter Six

Over a murmur of voices, I heard someone laugh— a familiar laugh. Was I dreaming? My heart raced when I looked up as the room turned quiet.

Judy Garland was entering the Fifth Avenue revolving door with an elegant-looking man. Of course— Vincente Minnelli! They were laughing, as if they were sharing the world's best joke.

Mr. Hutchison stepped forward to greet them and whisked the famous couple into the VIP private chamber behind the diamond counter. For a crazy moment I wanted to run up and say, "Hi, Judy! I'm one of your biggest fans!" I could see myself, sitting across from them in that special room, chatting about the old movies, the *Andy Hardy* comedies with Mickey

Rooney, Judge Hardy, and Aunt Milly. What fun that would be.

Instead, I waited patiently at the stationery counter for the salesman to finish writing his order. He had been sorting handcrafted vellum envelopes according to size in neat stacks. I thought he had missed seeing her, when he whispered.

"She looks very young, doesn't she?"

Young? Judy Garland is my age!

"Younger than her husband," I allowed.

He stared at me, surprised. "You mean that's her *husband?*"

Had he been living on the moon?

"They were married last week—he's Vincente Minnelli, the movie director," I explained. "They're here on their honeymoon—and have a penthouse on Sutton Place."

He made little clucking sounds as he nodded his head. Apparently, he'd missed the news of their glamorous wedding. Not us. Marty and I'd dash to the lobby of the St. Regis Hotel during lunch hour to read the latest. *Photoplay* had a breathtaking picture of them—Minnelli kissing Judy at their wedding; a pretty, smiling Judy holding a bouquet of huge pink peonies. She looked exquisitely lovely wearing a pale blue-gray

jersey gown and an organdy bonnet—*La Bohème* style—set back on her head to show her long reddish-brown hair. Not since the Duke of Windsor married "that woman" had I been so swept up by a love affair.

"They were just married in Beverly Hills—in Judy's mother's garden," I told the salesman, "and guess who gave her away? The head of MGM—Louis B. Mayer!"

More intriguing to me was that Ira Gershwin had been Vincente Minnelli's best man. With that cast of notables, the wedding music must have been exceptional. I combed through stacks of magazines at the St. Regis to find out what "their song" might have been. For a start, one of her favorites among Gershwin's was "Embraceable You," judging from her recordings. But what about "Love Walked Right In"? Ira Gershwin's lyrics would have been perfect, I thought, humming them to myself.

Love walked right in and drove the shadows away
Love walked right in and brought my sunniest
* day—*
When love walked in with you.

How romantic—that is, if anyone would have the nerve to sing in that crowd. If I had been included in that VIP room, I would have asked. Instead, I was

standing in the opposite corner, straining my ears. We heard whoops of laughter—that laugh as she walked along the yellow brick road. What was so funny? What could staid, old Mr. Hutchinson be saying? Did he know any jokes? Every time Judy's bubbly laugh ricocheted off the walls, everyone smiled.

I'd grown up with Judy—we were two years apart. From the front row of the Story City Theater, we'd seen her movies, memorized her songs, copied her hair style, and followed the Academy Awards and her career. Now, with her latest hit, *The Clock*, directed by Minnelli, she was MGM's biggest star. Had their romance begun when it was filmed here in the city?

Walter Winchell and Louella Parsons covered every detail. Now they were just as captivated by the Italian film director Minnelli. According to those gossip columnists, he was suave, sophisticated, worldly, charming, kind, elegant, cosmopolitan, dashing, a genius, and *mature*. Never a mention that he was old and almost twice her age, for heaven's sake.

When the newlyweds emerged from Tiffany's private chamber, I had goose bumps from head to toe. Minnelli's arm was around Judy's small waist, and her shoulder-length reddish-brown curls bounced like a little girl's. She looked up at him with a satisfied giggle as the doorman assisted them onto Fifth Avenue. They

disappeared in a limousine. All that was left was the smile on Hutchison's face.

Marty caught my eye—time for lunch. We quickly changed out of our Bonwit's dresses and headed for the Horn & Hardart Automat across Fifty-seventh Street near Sixth Avenue.

We went to the Automat *every* day, and I considered it a miracle in the same category as the wonder of Rockefeller Center. It was a dazzling room of chrome and carried the intoxicating aroma of freshly roasted coffee, hot cinnamon rolls, legendary macaroni and cheese, and delectable cherry pies (or so we'd heard). Our meal for the day was always the cheapest sandwich, usually egg salad, made with white bread. The Automat catered to everyone from bank presidents to girls like us, and the rows of sparkling chrome-and-glass compartments, the chrome-plated slots where the nickels went—even the brass dolphin-shaped spigot on the coffee urn, always glistened.

As soon as we'd inserted our nickels for our sandwich and a drink, we found our favorite window seat.

Marty was saying, "Minnelli is not exactly what you'd call handsome with that Italian nose—he's more the sophisticated type. So protective the way he held her hand."

"Held her hand? I missed *that*—but how did you like her piqué dress?"

"Linen," Marty said, sipping her iced tea. "And no hat—so California."

"Well, I wished they hadn't vanished into the VIP room."

"Who could blame them—every reporter was chasing after those newlyweds," Marty said, "though no one could miss that boisterous laugh."

"It was a resonant laugh—which carries," I said, remembering how happy Judy looked.

"I guess. But I'd love to know what Minnelli bought her. Remember, he'd designed a pearl engagement ring and a gold wedding ring with pearls—so maybe he decided to buy her a diamond, after all." We finished our sandwiches, and watched the lunch-hour crowd along Fifty-seventh Street as Marty took out a cigarette. "Who was that other man who tagged along?"

"What man?" I hadn't noticed anyone.

"There were three altogether," Marty insisted.

And she was right; later we read all the details. The mystery man was Nick Shenck, who had been sent by the studio with instructions to purchase them a Tiffany wedding present from MGM. Anything they wanted. Imagine, *anything* at Tiffany?

At first Judy had chosen a simple gold brooch, until Mr. Shenck encouraged her to try emeralds. Hesitating, she had tried on an emerald bracelet with square diamonds and a matching brooch that could be broken into two clips. She had laughed as she showed off the stunning bracelet. Mr. Shenck insisted that Minnelli, too, choose a present. His choice was an elegant gold Patek Philippe watch.

The emeralds were an exceptional choice. Symbolic, maybe? Something from the Emerald City to remember? I knew I'd always remember how happy Judy Garland was that day. Laughing and laughing.

106 Morningside Dr.

Dear Family,

What a week! Did you see the picture of the *Queen Mary* when it arrived? We were there when it steamed in from Europe—packed with over 14,000 servicemen and women! Guiding it into the harbor were dirigibles, aircraft carriers, tugs and ships tooting their horns. A band played "Don't Fence Me In," flags flew, and people carried gigantic banners with "Welcome Home" signs. It was so exciting when they came down the

gangplank—imagine how they felt hitting American soil. We cheered with thousands of New Yorkers till we were hoarse. I hoped I'd recognize someone from home, but I didn't. Red Cross ladies were dispensing 35,000 half-pint cartons of milk!! Did you know servicepeople could seldom drink milk in Europe? Of course, Mayor La Guardia and the military dignitaries welcomed them with fanfare, and the photographers and reporters were rushing around like crazy.

You'll never guess who came in to Tiffany! Judy Garland and Vincente Minnelli! You can imagine how thrilled we were to see them on their honeymoon. Their latest movie, *The Clock,* is a big hit; people are standing in a line around the block. It was filmed here in Manhattan with scenes of Grand Central Station and the Biltmore Hotel—the clock at the Biltmore is a famous meeting place—you can see why New Yorkers love it.

You wrote how *hot* it is at home—here, too! Nevertheless, the girls from Long Island will be here this weekend. Hot or not, they love our apartment.

Love, Marjorie

Our apartment was *never* too hot for those girls!
The phone again . . .

"Hi Sheila—Friday night?" Marty looked at me.
"Okay with us. . . . Can't wait to tell you the latest—
we just saw Judy Garland *and* Vincente Minnelli!" I
heard Sheila's high squeal over the phone from across
the room. Marty covered the mouthpiece and whis-
pered, "Anita."

"Hi Anita . . . you bet we did—saw them in per-
son . . . no, he doesn't look like a fuddy-duddy; you'd
fall for him in a minute. Did you read about Judy's
birthday party for her sister, Dorothy? They took over
La Martinique. . . . And she sang "Embraceable You"
with the Merry Macs—I hear she was a knockout in a
blue brocaded hostess gown!" Marty was fanning her-
self with a newspaper.

"There's a sale at Macy's? . . . *Two* pairs of heels?"
Marty asked as she turned to me.

That Anita! When we're limited to two pair of shoes
a *year*?

"Really—" Marty said. "No, we couldn't make it to
Macy's if they're giving shoes away—we only have an
hour for lunch. We're stuck out here," Marty sighed,
"shopping around our neighborhood. . . ."

"Where? At Bergdorf's, *m'dear!*"

We howled when Marty hung up.

Chapter Seven

We were sipping lemonade while sharing our Judy Garland story with Mrs. Shuttleworth when she suddenly realized she had forgotten to tell us something.

"Why don't you girls go to the midshipmen's dances? It's the patriotic thing for you to do."

Midshipmen's dances?

"Where?" we asked in unison.

"Right over at Barnard College—every Saturday night."

"Where's Barnard?" I asked.

"Oh, you girls." She shook her head. "Don't tell me you don't know? It's a girls' school next to Columbia."

"But can we just walk in if we aren't enrolled there?" asked Marty.

"Oh, for land's sake," Mrs. Shuttleworth counseled. "Just walk in like you're Barnard girls."

Barnard girls? How would Barnard girls dress for a dance?

Marty chose a tailored pink sharkskin dress, and I went with my sundress and white sandals. We freshened up our Stocking Stick–painted legs, and kept our pincurls in until just before we walked out the door. In this humidity, those curls wouldn't last long.

When we arrived, our confidence immediately dropped a notch. Women outnumbered the men at least two to one, if not three to one.

"These are rich girls. And they know how to dress," Marty whispered. The clothes looked straight out of *Mademoiselle*, and the hairdos were the latest styles.

"We could be hugging the wall for a long time," Marty acknowledged.

Someone put "Jeepers Creepers" on the phonograph, jitterbugging swept across the dance floor, and we headed for the punch bowl.

Four hours later, we were out of breath from running up three flights of stairs to the apartment. I slumped into the nearest chair, kicking off my high heels.

"Honestly—aren't they the *smoothest*?"

"Tell me about it! But just wait till I tell you the hysterical thing that happened"—Marty laughed as she went to the kitchen for ice cubes—"soon as I cool off— Good grief, *it is hot!*"

I was fanning myself with a newspaper when the telephone rang. Marty grabbed it.

"Hey—this is *not* Checker Cab." Marty slammed down the receiver. "And that's twice today." She handed me a glass of ice water and plopped down on the studio couch.

"Well, the *funniest* darn thing happened," she said, swirling her glass around. "Did you see the redhead I danced with first? He was from Harvard—had to mention it *twice*. Then my stupid Stocking-Stick goo came off on his whites—was he *mad!* That's when John asked me for a dance and rescued me."

"I wish I'd have seen that," I said, setting down my drink. "That guy has shoulders like a quarterback." I conjured up an image of John, though all I could think of was Jim.

My guy. I leaned against the back of the chair with "That Old Black Magic"—the song for our last dance—going round in my head. I noticed him immediately when we walked in. Who wouldn't? The other gals certainly did, the way they sidled up to him with-

out any shame—out-and-out flirting! He looked like Jimmy Stewart in *The Philadelphia Story* the way a lock of dark hair would fall over his forehead. When he approached me, I almost fell face-forward onto the dance floor.

"My name's Jim," he offered, with a hint of a smile.

He had an easy drawl and said he was from Virginia. When he found out I was from Iowa, he didn't blink an eye as we began to dance.

"You're a Southerner?" I asked.

"Come on—Virginia isn't the Deep South. Would you call Iowa the Old West?" He teased. "I recognized your Kappa key right away. Their house was close to our fraternity—we learned most of your songs."

"You're kidding—which one's your favorite?"

"Oh, you know the one—'*My girl's a Kappa—she chews tobacca.*'" He smiled and a lock of hair fell over his forehead again. *Ohmygosh!*

After our first dance, a couple began to jitterbug, elbowing us to the edge of the floor. Jim looked at them and raised his eyebrows.

"Not your style?" I asked, hoping he'd say no. It wasn't that I didn't like jitterbugging—I'd give anything if I could. But being so gangly, I didn't know what to do with my elbows.

He laughed. "'Fraid not." We found chairs in a far corner, and he brought over glasses of fruit punch. I couldn't wait to hear more about him. He told me he had a younger brother, had graduated with a degree in chemical engineering, and was a Phi Delt.

"Chemistry? That's *impressive*—toughest course I ever took. Organic chemistry was a real struggle."

"You took organic?" He looked surprised.

"Well, you know how they're urging girls to become scientists because of the war."

"Good idea—how'd you like setting up the lab?"

"That finished me—my Bunsen burner blew up the rubber hoses!"

He laughed. "So what's your major now?" His penetrating eyes gave me shivers.

"Actually," I hedged, not ready to confide about the cello, "I have so many interests—it's hard to settle on one. So, my roommate and I decided to try Manhattan for the summer and find a job. Believe it or not, we're working at Tiffany."

"*Tiffany!*" he echoed.

I continued as nonchalantly as possible; how we'd come to New York to find a glamorous job on Fifth Avenue, a pied-à-terre in Manhattan, and a chance to check out the nightclub scene.

Had I spread it on too thick?

Jim whistled and raised his eyebrows.

As soon as we heard the opening bars to "That Old Black Magic," we were on the dance floor again.

That old black magic has me in its spell,
That old black magic that you weave so well—

I adored the way he moved—

Icy fingers up
And down my spine
That same old witchcraft when your eyes meet
 mine.

Those brown eyes that penetrate mine.

That same old tingle that I feel
Inside—

And I loved how I fit right under his chin.

In a spin, loving the spin I'm in,
Under that old black magic called love.

Ohmygosh!

Were they blinking the lights? Time to go?

So soon?

"Yeah." Jim laughed. "We have curfew in the navy."

I looked around for Marty, and found her dancing with a tall football type. I pointed her out to Jim.

"Hey, I know that guy," he said. "His name is John."

How could we have been so lucky? Taking—*stealing* the cutest guys away from the "Bah-nad" girls. They'd never let us back!

Jim and John escorted us to the lobby of our apartment building. The desk clerk made an obvious point of watching our every move. Before they left, I held my breath and then heard the three most beautiful words in the English language. "How about next Saturday?"

Marty and I flew up the stairs without waiting for the pokey elevator, shrieking all the way.

One week later, I stood by the bedroom mirror trying out my eyelash curler, clamping it on like a vise.

"Do those things really work?" Marty asked, looking over my shoulder.

"Can't you tell the difference?"

"Ah reckon, so—*Tallulah,*" she mimicked. I knew she'd love it—we both liked the very latest. During our lunch hour we'd try on perfumes, turbans, and lacy gloves we couldn't afford. But that eyelash curler was mine. Aunt Olive had given it to me—I was shocked she'd heard of one.

"You might use this in New York," she told me. "One of the boys' girlfriends left it at our house."

Which one of my cousins had a glamorous girlfriend like that, I wondered? Probably Chuck, who was a dive-bomber pilot in the South Pacific and could attract girls from southern California and exotic cities like Pasadena, Beverly Hills, and Venice.

"Hey, better not paint any more Stocking Stick on your legs with navy guys," Marty warned. "So—what are you wearing?"

"I can't decide," I said, as if I had a closet full of choices. "Either my sundress again—or this blouse. Then again, it's so *hot*—the sundress. But then he'll think that's *all* I have. I just wish we knew where we're going."

"Probably a matinee—midshipmen get theater passes, you know." She went to look at the Broadway clippings tacked above the desk. "I think I'll suggest *Glass Menagerie*, with Laurette Taylor."

"How about the Astor Roof—with Gene Krupa?"

"Or *Myrtle Gertle*—how about the smorgasbord at the Icelandic?" Marty had the singsong Norwegian accent down pat.

I laughed till tears rolled down my cheeks.

Holy smoke—my *lashes*! I ran to the mirror. They were ruined. I washed my face and started all over again—when the doorbell rang. *They're here*. Barely

dressed in my black, I bolted for the door. There they were, Jim more handsome than I remembered. My voice was paralyzed.

"We thought we'd take you girls downtown—" Jim began.

"—To the Jack Dempsey Bar," John broke in, smiling broadly.

A *bar*? Were they kidding?

"Jack Dempsey—*the fighter*?" Marty asked, her voice sliding up an octave.

"You bet! The world champion prizefighter," John said.

Charmed, I'm sure, Marty muttered to me as we left.

It was a glorious sunny afternoon, the sky as clear and blue as a Tiffany sapphire. We waited at Riverside Drive near Grant's Tomb for the next bus. When it arrived, Jim took my arm to board and the four of us found seats on the top deck in the front row. On Riverside Drive, couples were strolling hand in hand along the leafy parkway, children were running with kites; and the rooftop terraces of the penthouses were dotted with colorful umbrellas. It was the kind of scene you'd see in a movie with subtitles and French impressionistic music.

But here we were, heading for a crummy saloon for boxing fans: pool tables, cigar butts, smelly spittoons, and counters sticky with spilled beer. No telling what riffraff would be roaming around. I couldn't believe it. Both of our dates were so nice.

What were they thinking?

"Here we are!" John exclaimed. In big letters, the sign read: JACK DEMPSEY'S BROADWAY BAR AND COCK-TAIL LOUNGE: THE MEETING PLACE OF THE WORLD.

As we walked through the door, and I caught my first glimpse inside, I gasped. *This was a bar?* Every bit of wood gleamed and hundreds of sparkling glasses filled the cabinets. I glanced at Marty, who rolled her eyes. John nudged Jim when a stunning brunette in a backless white chiffon dress was seated with a navy commander. A waiter ushered us to one of the uphol-stered booths. Along the wall was a colorful mural of a boxing match.

"Hot damn! That's Jack Dempsey and Jess Willard!" John pointed to the painting. "Must be their champi-onship fight."

"You're right," the waiter said, pointing out the art-ist's signature, too: James Montgomery Flagg. Marty and I looked at each other again. Everyone knew that name. Flagg's most famous poster, with the caption—

Uncle Sam pointing—*I Want You!*, was hanging in just about every public building.

We studied the mural in more detail: Jack Dempsey with his glove raised for a punch; the boxers with sweaty, sinewy muscles; and a crowd of men around the ring, wearing cocky straw hats, smoking cigars, and yelling at the fighters. It was so real you could smell and hear that fight. Our dates were talking excitedly to the waiter about the championship when a girl came by selling gardenias. Jim and John were easy marks.

"Why don't you wear it in your hair?" Jim suggested.

I melted. How could I have misjudged them? Why did I jump to such hasty conclusions?

The waiter took our orders for Cokes and beer. A photographer followed and snapped a picture—just like at La Martinique! I knew he'd be back in a little while with the photo, wanting us to buy it. *Does every fancy place in New York City have its own photographer?* When the photographer did return, Jim bought a cardboard-framed copy, for one $1.00.

The photographer didn't want us to miss any of the real celebrities, either. He leaned over to say, under his breath, "Don't look now, but Walter Winchell just arrived."

Walter Winchell! My eyes widened and I couldn't help but look.

Jim winked at me. "I'll bet this is a great place for him to pick up the latest scandal for his broadcasts."

"Do you think there's any chance that we'll see Jack Dempsey today?" I asked Jim.

"I don't think so," John answered. "He's a commander in the Coast Guard. I doubt he'll be back till the war's over."

The guys kept talking about Dempsey, and Marty and I kept watching the door, wondering who might walk in next. When the waiter returned, he was carrying menus.

"May I suggest a dessert?"

Dessert?

Did I ever think of anything else? Almost every day we'd walk past Schrafft's, with their fresh peach sundaes, peppermint sodas, and chocolate malts. Marty and I had been so proud, marching fast, not daring to glance, or to breathe. I could smell chocolate a block away. Just the other night I had dreamed of how my mother would pour hot chocolate syrup over chocolate cake with whipped cream. The next day we couldn't force ourselves away from Schrafft's. It cost us a whole week's allowance.

The waiter handed me a menu—my mouth watered as I read the list. There were *ten* tempting items, and too little time to consider carefully.

"Our specialty is cheesecake," he said.

Cheese cake? What will they think up next? I knew about weird sugar substitutes due to rationing, but a cake made with hard, yellow cheese? No siree. Not for me.

Everyone ordered the cheesecake.

I stared at the menu. "The rum ice cream, please." That sounded exciting—and sophisticated.

"With brandy sauce, Miss?"

"No—the strawberry sauce, please." The waiter raised his eyebrows.

I could scarcely wait. I'd share mine with Jim—he deserved it.

When the waiter arrived with the desserts, the others didn't have cake at all—it was a slice of velvety cream pie with a luscious-looking graham-cracker crust. They *raved*. They said they'd never had anything so delicious, *so* scrumptious.

No matter—my sundae looked wonderful, too. I took a large scoop.

Holy moly! What is this? The rum was strong—*real* rum, like in a stiff rum and Coke, and I had tasted only

a couple of those, on the sly at parties with preflight guys. And the sugary-sweet strawberry sauce? Mixed with the rum flavor, it tasted more like bad cough syrup. My eyes began to tear.

"How's yours?" Jim asked.

"It's—it's incredible," I stammered, trying to sound cheerful. I prayed I could finish. I had to—Jim had spent all that money. I'd try—or moosh it around the dish.

"Those strawberries remind me of my mother's shortcake," John said. "She piles on the berries over the cake with whipped cream—saves sugar stamps all year for it."

"What I'm homesick for is my grandmother's salt-rising bread—that's my favorite." Jim was smiling, remembering.

I had a flash—an inspiration. Of course guys love homemade bread. I could do that; I'd watched my mother kneading bread a hundred times. Easy. I'd just add a lot of salt. Our apartment would have that yeasty fresh-bread aroma and I'd look homey with an apron on—if Mrs. Shuttleworth had an extra one.

"Hey, look at the time." John jumped up. "We've gotta scram! I've got the watch tonight."

On our table, when we left, were the Coke and beer

bottles and a puddle of melting ice cream with a sorry-looking strawberry floating on top.

<div style="text-align: right">106 Morningside Dr.</div>

Dear Family,

Last night we went to a dance for midshipmen at Barnard—a girls' college. Marty and I met two very nice guys. The midshipmen are college graduates and train at Columbia University to become officers—they're called "ninety-day wonders." Marty and I had a fun double date this afternoon with them. They took us to—sort of an art museum with a stunning mural by James Montgomery Flagg!

Tell Katherine, all the stores in NYC are closed on Saturdays because of the war—*no* shopping on the weekends. Only the banks, restaurants, movies, and theaters are open. So the weekends are free for sightseeing, and our list is long—we *must* visit the beach of course!

And yes, I know exactly where Riverside Drive is—Aunt Cosette lived *there*? Very snazzy! And near Juilliard. We love taking that Riverside bus!

Love, Marjorie

P.S. Do you have a recipe for salt-rising bread?

Ooooh—that Riverside bus! On the way back, Jim and I squeezed into the last two seats on the top deck. When he reached for my hand, I prayed he wouldn't notice my calluses from the cello. I tried to hide them, to turn my fingers in—like Scarlett O'Hara. Maybe he'd think it was our hard work at Tiffany's. . . .

When we reached the bus stop at Grant's Tomb, Jim asked, "How about next Saturday . . . I know a place where we can sing college songs." *Ohmygosh!*

In a tumbler on our dresser, our gardenias faded and turned brown. But the scent brought it all back. Six more days. *Six whole days!*

Chapter Eight

"Why is it," Marty sighed, "that our lunch hour's *never* long enough?"

The choices were staggering when you worked at Fifth Avenue and Fifty-seventh Street, the luxury corner of the world. A glance first at Mainbocher's entrance (in case the duchess was in town), then to Bonwit's, and Bergdorf's, on to the rare-instrument shops, or to read *The New Yorker* in the lobby of the St. Regis Hotel. Also there was Sheila's friend who worked at Saks Fifth Avenue. The day we heard that she'd been propositioned by the manager, we couldn't run there fast enough to check him out. *Ohmygosh!* He was fat, bald, and *old*.

But that noon I was on a mission. Saturday's date with Jim meant finding a new dress that would be

dazzling and on sale. Fortunately, I still had the five-dollar bill Phil had given me, plus a few hoarded quarters—every last cent was needed. As Anita would say: "Money may not buy happiness, but it sure takes you shopping."

"Let's try Bonwit Teller first," Marty said. Around the corner, we sauntered past perfumes, lacy gloves, scanty Riviera two-piece bathing suits, and exotic Hawaiian dresses, but nothing was on sale. The haughty salesladies, in their classic black, never noticed us.

"Let's move on to Bergdorf's," Marty said, loud enough for them to hear.

Crossing Fifth Avenue with the Upper East Side ladies in their spiffy Lilly Daché hats and debutantes sporting golden beach tans headed for the Terrace Room at the Plaza, I felt out of my league in my scuffed saddle shoes. When I spotted a man lugging his French horn hurrying in the direction of Carnegie Hall, I smiled. At least I was following someone who knew a quarter note from a bank note.

"So where do you think the bargains are?" I asked Marty. Nothing set my heart racing like a FOR SALE sign.

"Hattie Carnegie?" She laughed. "No—Bergdorf's, like we planned."

"Are you *serious*?"

Bergdorf's wouldn't have a sale, I muttered, as we peered into their surrealistic show windows. But Marty was right; a SUMMER SALE sign was discreetly displayed. Once inside, the tantalizing scent of Chanel No. 5 sent me into a dreamlike trance as I milled around with the elite. How my mother would love this store. She had the greatest eye for high fashion and would have had one of the designers' dresses copied in no time.

As soon as we spotted the MARKED DOWN sign, we made a dive for it. Marty snapped up a pair of white gloves immediately—great bargain. Buried in the back, I found a crisp pink and white piqué dress, with a fitted bolero.

"It's five dollars!" I cried, showing Marty how the tiny pleats in the skirt billowed out like a Ginger Rogers dress, a show-off number to dance in. Even she gasped.

When I marched to the front counter to buy it, a snooty saleslady squinted through her chic glasses to examine the price tag.

"This dress is fifty dollars," she said, pointing to a tiny zero with her lurid red fingernail. Fifty dollars! Was she kidding?

I looked to make sure—that dress was meant for

me. How could a meager snip of a summer dress be on sale for *fifty* dollars? I almost keeled over.

When we left the store with Marty carrying her smart Bergdorf bag, I swore in Norwegian never to darken their door again.

As we crossed the street, my spirits lifted. Fifty-seventh Street was the Gold Coast with Carnegie Hall two blocks away and the high-fashion shops in between. So sacred to shoppers that the ashes of a grande dame had been scattered along the street. For me it was the place of rare-instrument shops on the second floor, with legendary names like Stradivarius, Guarnerius, and Tourte. Luckily, Marty was a good sport and tolerated my interest. We climbed the stairs hearing strains of a Bruch violin concerto before we entered the sunlit room smelling of rosin dust. Violins and violas were in special cabinets and cellos lined up against the back wall like soldiers.

"I'm only looking," I warned when I asked the luthier about a cello. He found a modern French instrument for me to try, and I played a few cadenzas.

"One moment, please," he said and returned with an old dark red cello with crackled varnish.

"This cello should interest you," he said, with a glance at Marty's Bergdorf bag. "Are you studying at Juilliard?"

"I'm afraid not—we work at Tiffany!" I said quickly, enjoying the immediate eye-opening reaction when they heard that magic word.

"This instrument is *special*," he said proudly, "Italian—seventeenth century."

It was more than special! I'd barely touched the strings to play the opening chords of a Bach saraband when the sound resonated through the store.

The timbre. Unbelievable! Marty's eyes were as big as silver dollars.

"Good night! What do you think Mr. Koelbel would say?" I asked her. My teacher, Mr. Koelbel, had searched Iowa for a fine cello; and cosigned a note for $350. Each month I'd been eking out the payments with my part-time jobs.

"That cello is a Carlo Guiseppe Testore," the luthier said. "A bargain at two thousand!"

Whoa! I looked at Marty.

"It's too nasal." Marty shook her head. "And I heard a wolf-tone."

I had taught Marty to say that so we could leave gracefully—but the sound wasn't nasal, it was glorious. Reluctantly, I handed back the cello. It had been effortless to play. *Effortless.* But two thousand dollars was a *bargain*? New York City was making me dizzy.

Marty tapped her watch. We were missing the

crucial time to stake out a window seat at the Automat to watch the lunchtime crowd.

"Hold on a minute," I said before we entered, looking down the street at the entrance of the Russian Tea Room, the famed restaurant next to Carnegie Hall.

Marty stopped, putting her hand on her hip. "*Not again!*"

"I'm just taking a peek," I insisted.

How could I admit my infatuation with Gregor Piatigorsky—that irresistible Russian, so tall his cello looked like a toy when he marched onstage like a Cossack. It was not a schoolgirl crush. Mr. Koelbel was a colleague of his, and had introduced me at a party after a concert. I almost fainted when Piatigorsky examined my hand for calluses, and then winked at me after telling the ladies, scattered at his feet, how he crossed the Volga River on his cello. But when he gazed at me with his penetrating eyes and said, "*Meez Maw-zhor-ee,*" I'd never been the same since.

"I'll bet anything Piatigorsky might remember me and invite us in," I said.

Marty pointed to her watch again. "Are you crazy? I'll bet he's an old married man—"

"Don't I *know* it—and to Jacqueline de Rothschild!" I'd read all about it in the paper—devastated, of course.

"But he said the Russian Tea Room was his second home with their pickled tongue, imported caviar, and vodka—"

There wasn't a sign of Piatigorsky in the Russian Tea Room, or on the way to Carnegie Hall. So we ducked into the Automat, grabbed a sandwich, and raced back to Tiffany like a pair of greyhounds.

106 Morningside Dr.

Dear Family,

We are so lucky that Tiffany is on Fifty-seventh Street—Carnegie Hall is only *two* blocks away. There are rare instrument shops in between and musicians all over the place. Someone saw Toscanini in a restaurant called the Russian Tea Room next to Carnegie!

I was so sorry to hear about Al Ose—after all these years as a Japanese prisoner! How ironic that it was one of our planes that bombed the Japanese ship he was on. Remember how the Ose boys played basketball at the end of the block? Please give them my condolences.

The girls from Long Island will be here again tonight—it gets pretty crowded on the weekends!

Love, Marjorie

Pretty crowded? It was a calamity! Anita was dressed to kill in an off-the-shoulder white eyelet dress, red heels, and dark glasses trimmed in sequins, with a navy lieutenant in tow. In the morning there were cigarette stubs in every ashtray, dirty dishes in the sink, peanut shells on the floor, and beer bottles lined up against the wall, to say nothing of nauseating stale beer fumes.

"Anita—who do you think cleans up around here?" Marty was furious.

"I'm sorry—I'm *really* sorry—honest to God. But I gotta run—the girls just left. *Tout de suite*," Anita pleaded, her hand on the doorknob.

"For crying out loud," I said, raising my voice, "don't tell me you're running off? Our dates will be here *any minute.*"

"I said I'm *sorry*. I'll make it up to you—no kidding. So . . . *Au revoir!*"

Chapter Nine

I was daydreaming at work about my Saturday after-noon date with Jim when Mr. Wilson suddenly appeared.

"Please come this way," he said urgently. We fol-lowed him across the main floor, passing two plain-clothes security men and Mr. Hutchison's counter, where there was the new string of pearls priced at a quarter of a million dollars that was the talk of the store. *A quarter of a million!*

Mr. Wilson hurried us to a nondescript door set in the paneled wall, a door I'd never noticed before. It opened into a small, narrow vestibule with an eleva-tor. The dead silence was broken when Mr. Wilson cleared his throat. "I need to show you how to operate

this elevator—it's a private one only for the Pearl and Diamond room." Marty and I gave each other The Look. I felt prickles crawl up my neck. The secret? The superintendent pressed a button, the elevator door opened, and he ushered us inside. I stepped carefully over the narrow crevice so it wouldn't catch my high heels.

When he pressed the top button on the panel, the door closed and we began to ride up, gliding smoothly, so unlike the shaky caged elevator at our apartment. When we stopped, we were on an upper floor and the door opened automatically. I was totally amazed. An elevator that seemed to run itself!

Mr. Wilson cleared his throat, adjusted his tie, and led us along a corridor to a large, brightly lit room. Two well-dressed men peered at us over a high counter.

"These are the young ladies I told you about," he said by way of introduction. The taller gentleman looked like my uncle Peter with crinkly crow's feet at the corners of his friendly gray-blue eyes. With no exchange of names—Mr. Wilson was a man of few words—we left as abruptly as we'd arrived, back to the elevator. He pointed out the button on the wall, the elevator door opened, and we stepped inside.

"Press this lower button to go down, but don't

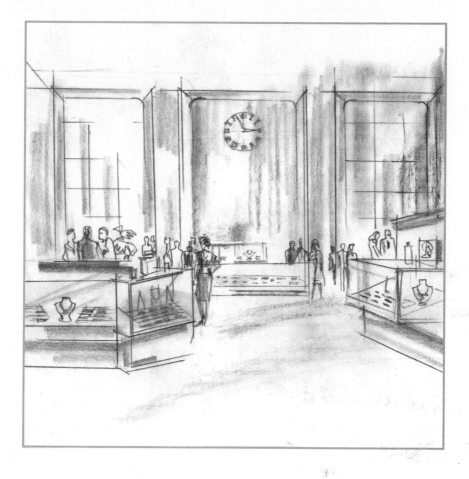

The main floor: diamonds, pearls, and gold jewelry;
watches and handbags; goldware and stationery.

Marjorie Jacobson's
senior portrait.

Marty Garrett's
senior portrait.

SERIAL

No. 13262622

Form W-2
U. S. Treasury Department
Internal Revenue Service

WITHHOLDING RECEIP͏ ͏15 **Employee's Copy**
For Inco͏ ͏ax Withhel͏ DUPLICATE

EMPLOYER BY WHOM PAID (Name, address, and S. S. Identification No.)

IDENTIFICATION No. 13 1367680

TIFFANY CO.
FTH AVE NEW YORK 22, N. Y.

| ͏ paid in 1945 | Federal Income Tax withheld | Soc. Soc. Tax Deducted | | |
| 220.00 | 24.00 | 2.20 | ☐ SINGLE
☐ MARRIED | |

EMPLOYEE TO WHOM PAID Print full name, address, Social Security No.

Marjorie L. Jacobson
106 Morningside Drive
New York, N. Y.

To EMPLOYEE: Change name and address if not correctly shown
APP. B. I. R. 12-27-44

Marjorie's W2 from the summer of 1945
from Tiffany & Co. Her total earnings were
$220, with $24 withheld for federal income
tax, and $2.20 deducted for Social Security.

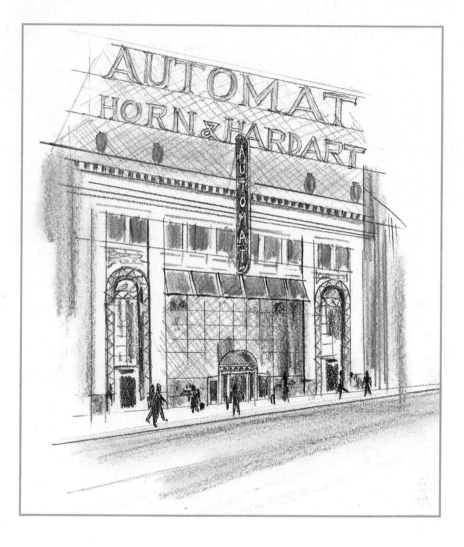

The Horn & Hardart Automat.

The sisters of Kappa Kappa Gamma
at the University of Iowa.

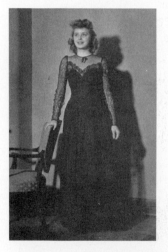

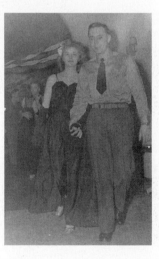

LEFT:
Dressed for a
Kappa dance.

RIGHT:
At the February
10, 1945, KKΓ
Pledge Dance.

Marjorie (first from
left) and Marty
(second from right)
with their Kappa sisters.

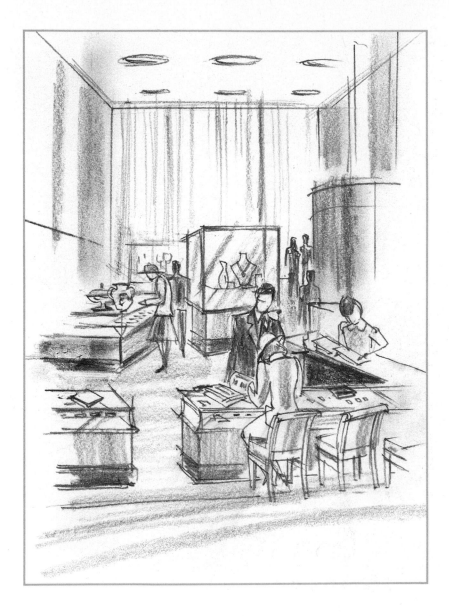

The stationery counter on the main floor.

Home sweet home—
the Seth Low building at
106 Morningside Drive.

A war ration book
and stamps.

The fateful postcard from Mickey Shuttleworth:
"I await with apprehension your
decision about this room . . ."

Schrafft's restaurant.

Marjorie's souvenirs from Jack Dempsey's,
La Martinique, Sardi's, and The Fraternity House.

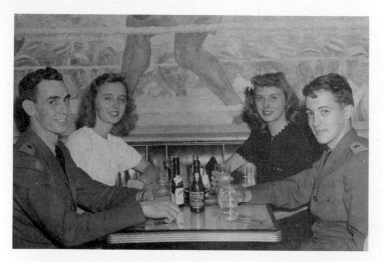

Marjorie's first date with Jim at the Jack
Dempsey bar. Marty and John (left)
and Marjorie and Jim (right).

The second floor: silverware, clocks,
leather goods, and the repair department.

Marty and Marjorie
at Jones Beach.

The Empire State Building.

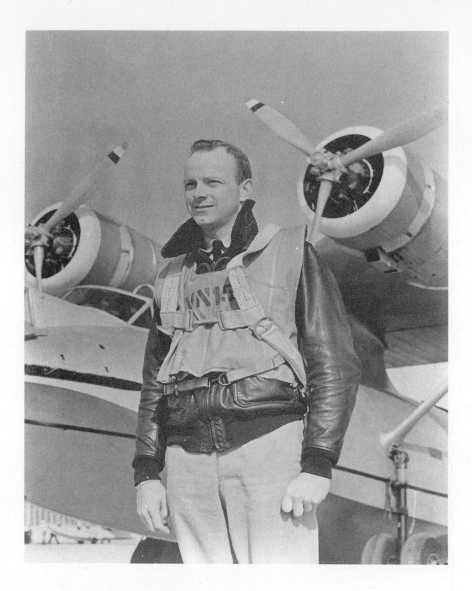

Marjorie's cousin, Paul Donhowe,
one of Story City's finest.

The third floor: china, glassware, and Mr. T.C.

Special table settings were displayed on the third floor.

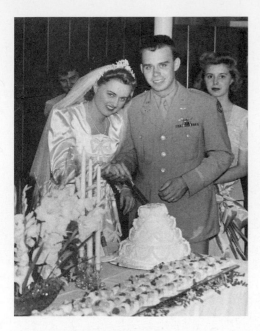

Katherine Jacobson's and
Dick Munsen's wedding,
September 17, 1944.

Hans Koelbel.

The Jacobson family in the early 1950s: Alfred
Jacobson, Marjorie Hart, Anna Jacobson,
Katherine Munsen, and Philip Jacobson.

The Astor Hotel.

Marjorie, following her performance with the University of San Diego Symphony in honor of her eightieth birthday. Her family and grandchildren filled the front row.

LEFT:
Marjorie at eighty-two years old.

RIGHT:
After visiting New York City in the winter of 1945 during the holidays, Marjorie didn't return to the Fifty-seventh and Fifth Avenue Tiffany store until 2004.

touch this red button," he cautioned. "It's only for emergencies."

Press the red button? Me? Not in a million years!

"This elevator is on a timed device that automatically goes back to the main floor."

When we reached the main floor, he swept his arm up with a flourish, and we waltzed out like a pair of Rockettes, our elevator lesson successfully completed. Running that elevator was simple and *easy*! I was thrilled that Mr. Wilson had finally revealed the Big Secret. What an honor and a privilege. I remembered reading about the secret room in Florence where the Medicis counted their money and what had happened to the workers who built it. Here we were, the new girls trusted with this extraordinary knowledge. A hidden elevator and a Pearl and Diamond room! I shivered!

Marty was the lucky girl to have the first honor.

"It's easy as pie," she told me afterward. "And once you're alone in the elevator you can sneak a look at what's in the case. I'm telling you, it knocked my eyes out!"

"You mean you *opened* the case?"

"You bet. You should have seen that necklace—all diamonds."

I could scarcely wait for my turn.

. . .

That big chance came the next afternoon when Mr. Hutchison carefully handed me a long, black velvet case. "They're waiting for this in the Pearl and Diamond room," he said, quietly.

Thrilled, I proudly made my way to the paneled door and entered the private vestibule. When I pressed the button on the elevator panel, it opened and I stepped inside. Not since I'd learned to drive had I felt that kind of power. After I pressed the "up" button, the door closed, and the elevator began to ascend. I reached in my bag for the case. I snapped it open.

Oh, no! Pearls—*loose* pearls—*so many*—spilled to the floor. *All over the floor!*

Real pearls bounce—bounce like popcorn! They leaped and danced.

I froze. How could I put them back before the door would open?

Ohmygod! That crevice—that long, open gutter!

When the door opened *automatically*—the unthinkable would happen. *The pearls would roll down and disappear forever.*

Horrified, I fell to the floor and stretched my legs along the door as a barricade. I could scarcely breathe

thinking of those pearls—*priceless* pearls—plummeting down that shaft. There they'd go—falling into greasy wheels, grinding gears, spinning belts, and God knows what! My heart was pumping a mile a minute.

When the door slowly opened on the upper floor, there it was—*that ugly narrow gap.* For the moment my little treasures were safe. But what could I say to someone waiting for the elevator, catching me crouched in a sea of pearls? Not a soul was around. By some miracle. For the moment.

Quick. Press the button. Close the door.

I inched myself closer to the panel and pressed the "down" button. Thank God, the doors started to close and I began to descend.

I tried to scoop the pearls up, but they slipped through my fingers as rivulets of sweat drenched my hands. The harder I tried to grasp them, the faster they rolled away. Dear heaven! This was an emergency! *The red button.*

No . . . no, no—Holy Toledo, no! Alarms would ring. Security would be on the run. Mr. Wilson, Mr. Hutchison . . . *President Moore,* for heaven's sake!

My heart beat so fast I couldn't think.

Don't panic! You're not supposed to panic.

Think. Think that it's twenty years from now, I told

myself. It wouldn't matter—this whole thing would be a dim memory. *Do not panic.* Or—twenty years from now I could still be doing hard time.

The door was opening—again!

I prayed feverishly, *Don't let anyone be there.*

No one. Thank heavens. Still, I was living on borrowed time.

I pressed the button to close the door. *Why wasn't it responding?* I tried again. Nothing. *Was it stuck?* Mercy—the wrong button—the top button, stupid, when you need to go up! But I couldn't reach it. I didn't dare move an inch. There was that horrible gap!

Desperately, I grabbed the jewelry case—reached—stretched—*and hit it! Whew—it closed. Finally.*

I couldn't breathe—I couldn't swallow—there was no air. Perspiration was running down my face. I felt my heart beating in my throat—and in my *ears!* If I could just breathe! I was getting . . . dizzy . . . lightheaded . . . *woozy. So—so—woozy.*

I must be dying!

Good heavens—if I died, they'd find me in a heap of pearls! Red-handed. What would everybody think?

Ah, but maybe they'd think I'd collapsed and the pearls had spilled out. And Mr. Wilson might say, "Not her fault, poor girl." They might even feel sorry for me. Better than the alternative.

Except I didn't want to die. I'd been so happy. Only last week Jim and I were dancing cheek to cheek. Would I ever hear our favorite song again?

That old black magic has me in its spell,
That old black magic that you weave so well.

I mopped my face with the edge of my skirt.

Icy fingers up,
And down my spine,

I'm going to cry.

When the elevator starts its ride,
Down and down I go—

Down and down the pearls go!—

In a spin—

Not this girl.

I started to breathe in gulps. Just shove them in the case any old way, I told myself. But the white satin case was slick; they pearls slid off the other side as soon as I set them *right in the middle.* Away they went. Like they wanted a life of their own.

Don't panic. Quick, before the door opens, pick each one up—one at a time. My hand was shaking so

much that the tiny ones slithered off and the larger ones shot over to the corners like billiard balls.

Then suddenly the darn door was opening!

I pushed the button *immediately*. It closed. I was going down again. Then it dawned on me. This could be a game of jacks! Just pick up a pearl, put it in the case, cover with my left hand—pick up a pearl, put it in the case, cover with my left hand—

I was playing jacks with priceless oriental pearls. I began to feel giddy.

I don't recall how long it took my clammy fingers to secure each precious pearl or how many elevator rides, but I do know my heart thumped so hard I thought the buttons on my dress would pop off.

When I'd retrieved all the pearls, even the tiny ones and those huddling in the corner, I snapped the velvet case shut. I swept the floor on my hands and knees to make sure I had every last one. Then I stood up. My wobbly legs barely supported me as I smoothed my skirt, wiped my face and hands, took a deep breath, and waited for the door to open on the upper floor.

I stepped out in a daze. The light blinded me as I made my way to the Pearl and Diamond room, expecting a blistering reception. I tried to keep my hand from shaking and to find my voice as I reached into

my bag for the case and handed it to the man with the gray-blue eyes.

"Here," I said, my voice shaking. "Here's the package from Mr. Hutchison."

"Thank you, Miss," he said, calmly. Opening the case, he examined the pearls and began counting. I held my breath until he said *nineteen—twenty—twenty-one*. To his assistant he said, "These are the pearls that need stringing."

You better believe they need stringing! My legs felt like Jell-O as I hobbled back to the elevator. As soon as the door closed, I burst into tears.

Later, when I told Marty, she howled. "Good night—what a story! What a *riot!*"

Easy for her to say. Not for me. I still shiver whenever I enter an elevator and stare down at that gaping black chasm below—a netherworld that was nearly my undoing.

106 Morningside Dr.

Dear Family,

You'll never believe this! I've learned how to operate an elevator. It's automatic—you just push a few buttons and it goes by itself! But the exciting thing is this—it's a special elevator that

goes to a secret room for pearls and diamonds! Doesn't that sound like something out of a movie? Have only had *one little* problem with it so far.

Jim, the midshipman I met, thinks he'll be sent to the Pacific when he receives his commission. We're going out again this weekend—he's from Virginia. I told him, Dad, about the time you introduced Babe Ruth at the celebration in the park—he was impressed!

Love, Marjorie

P.S. Remind me to tell you a scary story when I get home!

Scary? Downright *chilling*. I should be thanking God the pearls and I survived! Just thinking about it turns my stomach to mush.

I can see Jim's face when I tell him—he's such a *tease*! Whenever a band played "*Margie—I'm always thinking of you, Margie*" he'd kid me because he knows how I hate to be called Margie. Now he'll really have something to tease me about. I can't wait to see him Saturday.

Chapter Ten

Marty woke me in the morning, "Good heavens—do you hear rain?" I ran to the living room window to look at the brewing storm.

"It's already pouring!" I could barely see the brick wall. Now what? Umbrellas had not been packed on our trip from Iowa.

We threw on our scarves and our raincoats and were in the lobby within minutes; the floor was sopping wet with people stamping in and out. Marty begged the desk clerk for newspapers to cover our heads and we bolted for the subway. Settled in our seats, we noticed people staring. With sheets of dripping wet newsprint draped over our heads, we must have looked like escapees from a Peter Lorre horror movie. I started to

pick off the soggy shreds of paper stuck to my scarf, while Marty whacked away at her hair with a comb.

"We'll look like drowned rats!" I said, pushing my dripping hair off my face. "How did we forget to pack umbrellas?"

"Beats me," Marty said, "but I know a place where you can buy one with a sterling silver handle—"

I gave her a sharp look—this was not funny.

When we reached our lockers, the nurse ran for towels to dry our hair and sent a message to the secretary, "The girls are running a little late this morning." Our soft, dry "uniforms" had never felt better, though my pumps were soaked. Marty had tried to dry hers but they were drenched, too. "Oh, well," she sang.

When Marty and I reached our designated spot between the marble–framed mirrors, the two salesmen across from us smiled, looking fastidious in spite of the weather. The taller one, Mr. Myers, and Mr. Scott, were ardent Long Island clam diggers who had promised to bring us a bag of clams. Good night—what would we do with *clams*? Do they smell? Do you cook them? Are they alive? But we were flattered that they counseled us like we were little girls.

"At night," Mr. Myers had said, "don't you girls ever ride on the subway, and don't talk to those Bolsheviks

around Columbia." We didn't have the heart to tell them we had done both. But their warnings about how salesmen would tease pages with the rap made me laugh. And then I heard a rap from the watch counter.

My wet patent-leather pumps squeaked with each step on the way, sounding like yelps from a pathetic kitten. It startled the salesman, who saw me approach. When he finished with his customer, he handed me a check to take to the cashier. Trying to be quiet, I tiptoed, wavering like a tightrope walker to the cashier's cage.

Marty was waiting for me after I finished my errand. She tilted her head knowingly, in the direction of the Fifth Avenue entrance.

I followed her gaze.

Marlene Dietrich! Sun rays peeked through the Tiffany windows from the windswept clouds, catching her light blond hair. She didn't walk. She glided into the store with a regal air. Her bearing alone would have commanded anyone's attention.

Miss Dietrich proudly wore the mandatory olive-green khaki USO uniform, which carried the army insignia of a major. A perky army cap was nestled in her blond curls. Her feet were shod in regulation laced-up oxfords with old-lady inch-and-a-half square heels.

(What an affront to those famous gams, which had inspired the password "Legs" from General Patton!). The main floor was stunned into silence.

Marlene Dietrich had taken the city by storm. You could "Read all about it!" at the newsstand on the corner; the papers were filled with publicity from the moment she stepped on American soil from Europe. From her ship, she was carried to shore by soldiers, who hoisted her high over their heads, amid a wild, cheering crowd. Her USO work for the Allied forces had encompassed two years, longer than any other celebrity, a sacrifice in terms of her career. Reporters and photographers pursued her relentlessly.

In an interview describing her USO experiences, Miss Dietrich explained that she often rode in open Jeeps, endured shortages of soap and water, and ate regulation GI canned food. "Sauerkraut and frank-furters," she had said, "and always outdoors, often in cold rain, with water in the food and cold grease running all over." *Whoa!*

In one combat zone, she had wheeled dozens of injured soldiers to safety and declined special treatment for herself. "Sometimes I'd wrap up my sequined gowns for a pillow." The army adored her.

As we watched, she approached the middle counter

with a ravishing smile. The salesman lifted his eye-
brows in surprise—and awe. Usually celebrities would
head directly for the intimate and private VIP room
behind the diamond counter. Instead, Miss Dietrich
waited quietly like a regular customer, as unassuming
as a cloistered nun.

Marlene Dietrich was extremely beautiful, with
delicate features and translucent skin. As the salesman
helped her, she looked at him with an endearing gaze.
The back of his neck reddened as he helped her clasp a
jeweled bracelet on her slender wrist. They chatted as
she tried on several others. In a short period of time she
had made her choice. As he began to wrap the bracelet,
I glanced at Marty. *Was there anything we could do to
help? Weren't we needed here?*

It was then I noticed the tall, slender man with a
black raincoat standing quietly near the star. Rudolph
Sieber, her husband? As they turned to leave, she
nodded her head to thank the dazed salesman with
one more charming smile. As inauspiciously as she had
entered, the two of them left.

Caught off guard, I had stared, forgetting my Tiffany
manners. I knew better. I had learned from the six-foot
Fifty-seventh Street doorman how to be discreet.
The doormen were security officers and scrupulously

watched every customer, without staring. Focusing on the corner of the ceiling, you could "watch" every nuance and subtle move by using your peripheral vision. The doorman would murmur, "Henry Luce is at watches" or "Mr. Gould to your right, Miss" (I saw his difficulty in reaching the counter due to his formidable girth!). "You just be patient," the doorman promised. "This is the door where the duke and duchess enter—after her fittings at Mainbocher." Having been told that the duke had made frequent visits to Tiffany to see the latest gems, I found every excuse to be near that doorman.

Marty and I, on the other side of the cashier's cage, had followed every move of Miss Dietrich, a distance away. John Wayne had said, "Marlene Dietrich is the most intriguing woman I ever met," and we didn't want to miss a thing. There were lessons to be learned, I figured, from someone that charismatic.

At lunchtime, due to the rain, Marty and I stayed cooped up in our locker room, sitting on the bench as we stuffed our shoes with newspapers, and searched our purses for leftover crackers.

"That was Rudolph Sieber all right—his picture was in *Time*," Marty reported as she finished a stale cracker. "What gets me—she has this nice guy for a

husband, who patiently waits for her, while she's running around with Douglas Fairbanks, John Wayne, Gary Cooper, Edward R. Murrow . . . and General Patton!" She scoffed. "Did I forget anyone?"

"Ernest Hemingway, Marty."

Marty rolled her eyes.

"For gosh sakes," I said, becoming a little heated, "give her a break! Most of her admirers are intellectual—and so is she."

"*General Patton?*"

"You bet—he comes from California and belongs to a scholarly set with the Huntington family! Besides that, she was a violin protégée in Berlin—"

"The *violin*? I thought she played the musical saw."

"I guess I forgot that." I made a face. "But she's a genius, nevertheless." I'd read that her mother bought her an expensive violin, a great sacrifice for her, knowing that Marlene was gifted as a young girl.

"Huh?"

"That's right. She read German fairy tales when she was four—and could speak French!"

"Well, do tell." Marty was trying on her shoes. "She's attractive, I'll give her that—but skinny as a rail. Like your '*You can't be too rich or too thin*' duchess."

"She's thin from *exhaustion*—the paper said she

needed a long rest," I said, rushing to her defense again.

"Sure," Marty laughed. "At the St. Regis no less—reading letters from Hemingway or making a play for Salvador Dalí in the Iridium Room."

"Salvador Dalí—at the St. Regis?" I asked.

"You bet. Think how great they'd be together—she's as surreal as he is."

Marty had a point, but Marlene Dietrich was fascinating to me, ever since I read that she'd studied at the Music Academy in Berlin with the famous violinist Carl Flesch. I marveled at her talent. Was it her fault men dropped dead at her feet? I could learn a thing or two from her myself.

 106 Morningside Dr.

Dear Family,

What's new around here is that we may have a new roommate, a friend of the Shuttleworths'. We hear she's lovely—I'm sure she'll fit right in. Marty has offered to take the studio couch in the living room for the rest of the summer.

If that wasn't enough excitement—who should walk into Tiffany's but *Marlene Dietrich*! She looked more glamorous than in her pictures—

even in a USO uniform! The most interesting thing to me is that she studied with Carl Flesch! Ask Katherine if she remembers practicing from that Carl Flesch Scale System book—those scales every morning? Phil and I do!

You asked if I'd been practicing the cello. We've been too, too busy.

Love, Marjorie

P.S. Had a lovely dinner with Bill Craig. Please tell his mother the next time you play bridge.

Too busy whipping things into shape for the new girl! The big deal is splitting the rent—that's a plus; with a little extra money we can all see the smash hits on Broadway—even *Carousel*!

As for dinner with Bill Craig, he took me to a fantastic supper club in Greenwich Village, Salle de Champagne, with marvelous food—all French dishes I'd never even heard of. It was the first real meal I'd had since arriving in New York—though I didn't let on. How fun it was sharing the latest news about Story City.

And what would my family think if they heard that we'd eaten snails with champagne?

Chapter Eleven

Jack Cavanaugh, the Irish clerk in the shipping department, looked at me and said, "So—ain't seen the Empire State Building yit?" Throwing his hands in the air, he said, "Sure, you kin see five states from there! What are you thinking of?"

"Five states?" Of all the tall tales about the Empire State Building, I'd never heard that one. "Don't worry—we have it on our list."

"A list!" His eyes widened. "The tallest buildin' in the world—on a *list*? Ah, I'd walk past it every noon just to admire't—that's when we were at the old store. . . ." As soon as he said "the old store" in that wistful tone, I smiled. If Jack wanted to reminisce about that store all day, I'd be there to listen. Tiffany's was known as the

"Venetian Palace," on Thirty-seventh Street and Fifth Avenue, and there were giant pillars, seven stories high, surrounding the building, modeled after the Palazzo Grimani in Venice. It had been hailed by the press as "the highest mark of artistic excellence."

Pushing his glasses up onto the bridge of his nose, he continued eagerly, "Oh, lass, you should'a seen it at Christmastime—golden garlands around the silver chandeliers, made by our own silvermen, and Christmas trees fancy as wedding cakes. Ah, the chauffeurs with their fine uniforms with all them buttons would drive up to the entrance wit' the *lydies* dressed to kill, wearin' enough pearls and diamonds to buckle their knees. Then Mr. Jansen—Mr. Tiffany's chauffeur— would drive up in that *swell* cream-colored Stutz Bearcat with the wire wheels sittin' on the running board . . . and he'd swap stories wit' us—like in your Story City where you're tellin' tales all day long."

It was true. Early in the morning the old folks gathered at Alsager's meat market to speak Norwegian, the quilters in the church basement could trace every family back to the Runic Stone, and at every wedding, Story City's church balconies were filled with uninvited rubberneckers looking for the latest gossip.

"And at Christmastime," I told him, "we had a giant

Christmas tree in the center of town, and our church was packed for the Junior Choir's candlelight program, with a walnut carved candelabra ablaze with twenty-one candles, copied from one in Norway. Maybe not so fancy as those you saw, Jack, but ours was made by our own Norwegian craftsman." The memory almost caused me to tear up.

When I described how the *Story City Herald* was sent to Norway every week, it made Jack's eyes dance.

"So tell me that joke of your father's," he said, leaning forward, "the one you promised me."

I laughed. "I can't tell it as well as my dad, but it goes like this—

"There was this Norwegian by the name of Ole, who just got off the boat, and his cousin from Story City went to meet him. He was so proud to show him the Empire State Building, but disappointed by Ole's reaction.

"'But, Ole,' he asked, 'isn't that the tallest building you've ever seen?'

"'Yah,' he answered, 'but vait till ve see *Story City*!'"

Jack laughed, wiping his eyes with his handkerchief, and had me repeat it to the others in the back. I knew it was time to leave, past time. But it was his turn for

a story, and I was mesmerized by Jack's stories and his brogue. The elegant way he enunciated *Tif*-fany with the gentle lilt on the first syllable. When I commented on his *Tif*-fany, he said,

"'Tis an Irish name, lass."

He shook his finger before I left. "Don't ye be putting off going to that great building. And soon. Why not tomorrow?"

I said we would; it was the admission fee that was holding us back. The elevator to the observation tower was not cheap. It cost over a dollar!

Saturday morning Marty and I were asleep at just before ten, when we felt a sudden jolt. Marty sat up, startled. I ran to the window. "What was *that*?" she called.

"Can't see—the fog's too thick," I said, dashing for my clothes. "I'll go to the lobby and find out." Halfway out the door, I heard our Russian neighbor shrieking, "It's a bomb—a bomb!" I headed for the stairs, not waiting for the elevator. In the lobby, people were gathering around the radio.

The startled desk clerk turned to me. "The Empire State Building—*a plane crashed into it*!" I was shocked—and moved closer to the radio. An army

plane . . . lost in the fog . . . the Empire State Building was on fire! Unbelievable.

I ran up the stairs two at a time to tell Marty, urging her to join a group of us leaving for downtown.

"It's too foggy," Marty said, putting on her slippers. "I'm not ready—you go ahead." I grabbed my purse and joined a gaggle of people waiting for the Riverside bus, passing shadowy shapes half hidden by the fog. We asked each other if the buses were running, but soon saw the headlights of one approaching. It was crowded as we squeezed our way in—everyone talking at once. Reaching midtown, the bus driver announced, "Everybody out, can't go any farther."

The police had cordoned off the streets and a misty drizzle filled the air; a fire siren wailed a block away. Though the weather obscured the Empire State Building, I overheard snatches of conversation as more people surrounded us with umbrellas: "It sounded like a train wreck—" "I heard the roar of the plane and then this *horrible* explosion—" "There was screaming in our hotel—we saw flames down the whole building—" "Remember the man who jumped off the tower and killed a tourist—something bad is always happening."

A stocky woman holding a striped umbrella spoke up. "My office—it's on the thirty-second floor. I was

there yesterday," she said tearfully, as if the Empire State Building were a person and a treasured family member. She tried desperately to get a glimpse of the building, but the dense fog hung like a gray sheet. Black smoke mixed with water circled above.

It wasn't long before the acrid smell became over-whelming. I coughed as my eyes smarted from the caustic fumes. I recognized that bitter smell. I knew it all too well. When I was a freshman at Iowa State College, in Ames, a fire had started in the chemistry building's third floor while I was in a lab class on the second floor. We ran for the door at the first sign of smoke, but a guard would not let us leave our lab. We ran to the windows—fire trucks and the firemen were below, looking up at us, while billows of black smoke poured out from above.

That third floor! So secret that there was a guard posted each day at the entrance to the building, and the stairway was blocked above the second floor. Every-body knew it was a top secret war project, but that's all we knew. After the fire was under control, not a word of explanation was offered. *Nothing to worry about*, we were told.

That pungent smell of smoke had haunted me ever since, and this time it made me queasy. Maybe a half

hour after our arrival, a harried policeman dashed over. "Nothing you folks can do here—move along now."

I couldn't leave fast enough.

When I reached our apartment, Marty wasn't there. At first I thought she was at the Shuttleworths', but when I checked, they hadn't seen her. I asked the desk clerk, but he shook his head. I checked with the elevator operator. Yes, he had taken her to the lobby. All I could do was wait. And wait.

When she finally burst in late that afternoon, I jumped. "Where have you *been?*"

"Where *haven't* I been is more like it!" she groaned, slumping into the couch, her coat dripping. "I decided to go and see it—it seemed to be the only way to find out anything. Then of all the dumb things"—Marty stopped to catch her breath—"when I was ready to come back, I realized that I'd left my coin purse. I didn't have a red cent—*nothing!*"

What she did have, she explained, was a fifteen-dollar check from her father. He had wanted her to visit Washington, D.C., while she was on the East Coast.

"I knew the stores were closed because it's Saturday—but I finally found a bank open, and tried to act

like I knew what I was doing, without a stitch of iden-
tification. I was lucky they'd cash it."

"Honestly, Marty—cashing all that money for one
single nickel?"

"I did think about jumping over the turnstile—but
if I'd been caught—then what?"

She reached for an ashtray from the couch, and I
ran to the fridge for ice water, relieved she was back
safely. In the kitchen I saw the clock.

Ohmygosh. Jim would be at the door in half an
hour. My hair—straggly, straight, a mess!

"Try a scarf," Marty volunteered. I found my blue-
fringed scarf, but still my bangs hung straight down like
Mamie Eisenhower's. And it was five forty-five. Jim
had never been this late. I jumped whenever the phone
rang, my pulse racing, trying to pretend I didn't give a
hoot. I fooled around with the scarf, tying it in front,
in back, behind the ears, and in an inspired moment, a
Dorothy Lamour–style turban.

"*Ta-da!*" I turned to Marty as I tucked in a few
loose strands.

She bit her lip. "Better—but you need big dangly
earrings—and a *sarong.*"

I tied the scarf back under my chin. What difference
did it make? How could I fuss about my hair after what

had happened today? Innocent people had been killed and families torn apart forever.

The clock said six-thirty. *Seven!* I felt like Madame Butterfly kneeling all night waiting for Lieutenant Pinkerton. But Jim wasn't like that; he'd never stand me up. Common sense told me there had to be a reasonable explanation. It could be related to the Empire State Building, or a lockdown of the navy. He'd call the next day. Of course he would.

Early Sunday morning, July 29, we went to the Shuttleworths' to read the *New York Times*, gasping together in horror at subheadlines, such as "2 Women Fall 75 Stories" and "Motor Hits Another Building," and with relief at one that read "Many Offices Unoccupied." Our eyes swelled with tears and we shook our heads in disbelief when we saw the front-page photo of the gaping hole torn between the seventy-eighth and seventy-ninth floors.

We read the headline over and over, and read the article several times, our hearts going out to the families of those who'd met such a desperately sad fate the previous morning. I kept having to remind myself that it was not a dream.

The paper, in part, read:

B-25 CRASHES IN FOG

HOLE 18 BY 20 FEET TORN THROUGH
NORTH WALL BY TERRIFIC IMPACT

BLAZING "GAS" SCATTERED

FLAMES PUT OUT IN 40-MINUTE FIGHT—
2 WOMEN SURVIVE FALL IN ELEVATOR

By Frank Adams

A twin-engined B-25 Army bomber, lost in a blinding fog, crashed into the Empire State Building at a point 915 feet above the street level at 9:49 A.M. yesterday. Thirteen persons, including the three occupants of the plane and ten persons at work within the building, were killed in the catastrophe, and twenty-six were injured.

Although the crash and the fire that followed wrecked most of the seventy-eighth and seventy-ninth floors of the structure, causing damage estimated at $500,000, Lieut. Gen. Hugh A. Drum, president of the Empire State, Inc., Corporation, said last night that an inspection by the city's building department and by other engineers and architects showed that the structural soundness of the building had not been impaired.

Landing Advice Disregarded

The plane, en route from Bedford, Mass., to Newark on a cross-country mission, had flown over La Guardia Field a few minutes before the crash, and its pilot, Lieut. Col. William F. Smith Jr., deputy commander of the 457th Bomber Group and recently decorated for his service overseas, was advised by the control tower to land. Instead he asked for the weather at Newark Airport and headed in that direction.

Horror-stricken occupants of the building, alarmed by the roar of engines, ran to the windows just in time to see the plane loom out of the gray mists that swathed the upper floors of the world's tallest office building. The plane was banked at an angle of about fifteen degrees as Colonel Smith swung it in a curve out of the northeast.

It crashed with a terrifying impact midway along the north, or Thirty-fourth Street, wall of the building. Its wings were sheared off by the impact, but the motors and fuselage ripped a hole eighteen feet wide and twenty feet high in the outer wall of the seventy-eighth and seventy-ninth floors of the structure.

Brilliant orange flames shot as high as the observatory on the eighty-sixth floor of the

building, 1,050 feet above Fifth Avenue, as the gasoline tanks of the plane exploded. For a moment, watchers in the street saw the tower clearly illuminated by the glare. Then it disappeared again in gray murk and the smoke of the burning plane. . . .

Fire Commissioner Patrick Walsh, who arrived to take personal command of the fire-fighting, said the blaze was the highest one in history, surpassing even the celebrated Sherry-Netherland Tower fire of 1927, but that it was a comparatively easy one to extinguish. The flames were put out within forty minutes. . . .

Flight Started at 8:55 a.m.

Colonel Smith was a native of Alabama, where his parents, Mr. and Mrs. W. F. Smith, still live. . . . He was a varsity lacrosse man and a member of the football squad at West Point, from which he was graduated in 1942. He had completed 100 missions over Germany, and was only recently decorated for his combat services. . . .

Archbishop Spellman issued a statement last night expressing his sorrow at the catastrophe. The Chancery Office of the Archdiocese announced later that prayers would be offered in all of the city's Catholic churches

today in memory of the dead, for the consolation of their relatives and for the recovery of the injured.

Archbishop Spellman will celebrate mass at 9 A.M. in St. Patrick's Cathedral with the same intentions, and a special pontifical high mass of requiem will be sung by the Archbishop for the dead at 10:30 A.M. Wednesday.

"Did you read about La Guardia?" Mrs. Shuttleworth asked, tapping her finger against the paper. "He risked his life entering that burning building! But, land's sake, on weekdays, there are ten thousand people working there. Good thing it was Saturday!"

"Or hundreds of tourists if it hadn't been so foggy," Marty added. I shivered. "And it could have been us, if we'd had the money."

106 Morningside Dr.

Dear Family,
 What a catastrophe!! We felt the crash here—our building rocked! I hope you didn't worry about me—I did go downtown, but couldn't see a thing with so much fog and smoke. Mayor La

Guardia was the hero—a real Superman. Imagine taking an elevator up in that burning building! No wonder New Yorkers are crazy about him!

I thought of you, Dad—joining the volunteers during all the fires. I'll never forget those two rings on the telephone in the middle of the night and then you'd have to run downtown to get on the fire truck. The smoke reminded me of the chemistry building fire, too. Does anyone know what that war secret is all about?

Please save the *Life* magazine—without a radio we don't hear all the news.

Love, Marjorie

No news from Jim, that's for darn sure. *Not a single word all day Sunday.* My head is spinning with excuses.

But it paled in comparison to the news that filled the newspapers. This tragic crash had changed so many lives.

Chapter Twelve

The store buzzed with the question: "Where were you on Saturday?"

The elevator operator told us his friend had been rescued from the sixtieth floor. Mr. Myers said that the landing gear and part of the engine had landed on the Waldorf building, and Mr. Wilson was excitedly talking about Mayor La Guardia as if he had put out the fire himself. Everyone was in shock over the Empire State Building.

At the first possible moment, I went to the shipping department.

"Hey—Cavanaugh!" a clerk called.

"There she is!" Jack ran in. "You didn't go up there, did ya?"

"In *that* fog?" I asked.

"I told the missus," he said, shaking his head, "if anything'd happened to you girrls—I'd break in two!"

I was touched that he cared. "I came down as soon as I could—I can't imagine anyone going there when it was so *foggy.*"

"Oh, lass," he said, "they're up there in all kinds of weather. You just have the luck of the Irish!"

I could use that luck, too, I wanted to add.

Later that morning, Mr. Myers signaled to me.

"We have something special you'll want to see— I just showed Miss Garrett," he said as Mr. Scott brought out a shimmering silver tray and placed it on the counter. When he lifted the cover, I was amazed. It was a complete vanity set in sterling silver. Silver comb, brush, mirror, perfume atomizer, cream and powder containers, manicure set, and a case for special jewels. All fitted in special compartments.

"An American Art Deco design," Mr. Myers said, proudly.

I couldn't take my eyes off the dazzling set. Who wouldn't die to own it? The lady who deserved it was my mother. I could picture that shining vanity set on her three-way-mirrored dressing table. As a little girl, I loved to lie on Mother's bed and rest my chin on her

black sealskin muff that I'd find in the cedar chest. She'd brush her glossy black hair, pin it in a roll, and powder her face, the loveliest in town.

"I imagine it's very expensive," I said as he placed it back on the first shelf of the counter. "Yes," he answered, "it's very dear," but he quickly changed the subject, for money was never discussed. "Isn't it lucky that you girls weren't in the Empire State Building?"

Before I could answer, I heard a loud rap.

It was Mr. Herdman. I could see his lips pressed in a thin line, and his shoulders were squared in a military stance when I reached his counter.

"Mr. Herdman—sir?" I asked, trying to sound cheerful.

He looked at me intently. "Miss Jacobson, I need to ask about a package I gave you last week. Did you take it to the mailroom?"

That stopped me. "I take every package for mailing there—sir."

"We've been checking"—he cleared his throat—"and the customer did not receive it. I'm sorry this has happened."

Sorry? *Sorry?* I was mortified! A package I'd delivered?

"I'm sorry, too." Good heavens—did he think I was at fault?

"You're sure you delivered it?" he insisted.

"Yes, sir," I said, barely able to answer.

When he finally dismissed me, I felt a lump in my throat swelling to the size of an orange. I tried to force back the tears. I focused on the ceiling as if I were searching for cobwebs.

I looked for Marty.

What could this mean? A locker room search? A call from President Moore? *New York police at our apartment?*

As soon as Marty stepped out of the employees' elevator, I ran to meet her. "I have to talk to you!"

"Lunchtime," she called as she hurried by.

At noon we headed for the Automat. I looked over my shoulder to see if we'd been followed.

"What in the *world*?" Marty asked.

My voice cracked as I spilled out the news, the accusation.

Marty's eyes widened. "For crying out loud, there's nothing to worry about—you're innocent until proven guilty. My father drilled that into me . . . just march right back and tell old Herdman—or J. Edgar Hoover."

For the moment, her father's legal knowledge reassured me; he'd tried cases before the Supreme Court, he was the expert. I tried to calm down as we headed back to Tiffany's. But I avoided Mr. Herdman. I'd

never confront him. As the day wore on I imagined the disgrace of being canned and fingerprinted and ending up in court. What would my parents say?

By the time we returned to our apartment I was beyond speech. Marty was buffing her nails at the desk. "You still worried about old Herdman? I'd tell him to go soak his head."

"You wouldn't dare!"

"Actually, I did!" She looked up. "He came after me first—you know how they mix us up. But when I took business law last semester, I learned you can't accuse anyone without proof." She blew on her nails, and laughed. "You should've seen his face when I told him *that*!"

Still, it didn't help me sleep any better. In fact, my eyes never closed as worries flew around like a movie on fast forward. Why couldn't I be like Marty? When Mr. Herdman confronted me, my face had turned crimson and I'd stammered as if I had been caught red-handed.

Why did I always feel so guilty? I remembered when my fourth-grade teacher had discovered that money had been stolen from her desk. She had marched up and down demanding to know who the culprit was. No one raised a hand. While my friends laughed about it at recess, I felt compelled to go to her and prove my innocence.

All night, staring at the ceiling, I retraced my steps from Herdman's counter to the mailroom. I enjoyed reading the stylish names and addresses on the handsomely wrapped packages. Wonderful aristocratic names and addresses like Mrs. Thurston Johnston in Oyster Bay, Mr. Cornelius Haynes on Park Avenue, or the Stuart Stuyvesants on Nantucket. I was sure that if I'd read the name on that missing package, I'd recognize it. I would reassure him I'd taken it to the mailroom. It was nearly dawn before I drifted off to sleep.

The next morning I voiced my fears again.

"Hell's bells, Marjorie!" Marty stared at me. "I'll bet even Mr. Wilson doesn't know a thing. Don't tell me you're still worried?"

I was worried sick.

As soon as the store opened, I went to see Mr. Herdman, my hands trembling.

"Sir—" I said, trying to sound casual and matter-of-fact, "I was thinking about that missing package. If you could tell me the customer's name . . . I'd know if I'd delivered it."

"How would you know?" he asked, surprised.

"Sometimes—I read the names." There was silence. My throat was tight, and I flinched from his curious gaze.

"I'll think about it, Miss Jacobson," he said as he dismissed me.

I instantly regretted it. Why trouble *trouble*? Why hadn't I listened to Marty? I tried to look cheerful, but my forced grimace lasted only to the elevator.

When I returned, Mr. Myers motioned to me. Did he know, too? I felt as if I had the scarlet letter *T* for thief emblazoned on my chest.

"I thought you might like to know," he said, lowering his head, "how my wife makes clam chowder." *Clams!* I started to breathe again. I could discuss clams all day. I peppered him with questions as he recited the recipe. What kind of a pan, how much salt, how long to cook it . . . I hoped we could continue until closing time.

Then, a rap—a loud one from Mr. Herdman. *Holy moly!* My legs felt like two wooden sticks that required operating instructions. I inched forward.

"Miss Jacobson," he said, tapping a gold pen, "I thought about your suggestion and I've a list of ten names. Please tell me which one you might recognize."

That is not what I had in mind!

When he read their names, I couldn't identify a single one. Hearing them was different from seeing them in print. I was a goner.

"I'd like to hear them once more," I pleaded, pulse racing.

He read each name again in a grim monotone voice. I became confused. I swallowed hard.

"Could you please include the first names?" I wished I could drop through the floor. He repeated the names once again, not hiding his impatience. When he read "Marybelle Wetherwell," I drew my first full breath. Thank heavens.

"That's the name! I remember. It's such a—musical name—it rhymes!"

He looked surprised. "Why would you remember that name?"

"Who could forget it?" I asked. "Trust me, her package got delivered."

Was that a smile or a frown on his face?

We never heard after that if the package had been lost, stolen, or found on someone's doorstep. But to my great joy, the subject was never mentioned again.

106 Morningside Dr.

Dear Family,

Our new roomate has arrived. Her name is Carolyn. She's a lot of fun and loves the theater. Now that she shares the rent we can go, too.

Can you believe we saw Fredric March in the lobby of the St. Regis! He's the star in the Broadway hit *A Bell for Adano,* and after we

spotted him, Marty, Carolyn, and I decided we had to get tickets. The theater is not much larger than the Story City Theater, so we had excellent seats. We also stopped at Rockefeller Center on the way. Amazed at the glamorous shops there!

I hope you don't think my job is all glamour and watching famous people. There's a lot of responsibility, believe you me!

Life couldn't be more perfect!

Love, Marjorie

My eyes welled as I wrote the word "perfect." *Everything* is a disaster. What about Jim? I stare at the phone, willing it to ring. He must have a girlfriend in Virginia. That has to be it. She's probably here visiting and I'd bet anything she's a Kappa—he knew all the songs backward and forward. How could I miss that clue?

Then when Carolyn moved in, we were so embarrassed. We couldn't squeeze all of her clothes in our tiny closet, black bugs were crawling on the stove, and she almost sat on a caterpillar on the chenille chair. Honest to Pete!

If that wasn't enough, I accepted a date with a guy I'd met in U. of Iowa's preflight program. I barely

knew him, though he was certainly a nice guy—tall with red hair and a trace of freckles. We thought we'd go to the Astor Roof—Gene Krupa was there—and it would be so cool dancing outside. But the joke was on us. "The Roof" was the top floor, over ninety degrees, jam-packed with sweaty dancers bumping into each other. Gene Krupa's drumsticks were flying, and he was chewing gum faster than the beat. Even the best jitterbug dancers couldn't keep up with his lightning version of "Boogie Woogie Bugle Boy." And I sure couldn't keep up with my date!

But I really wished my date was Jim. We wouldn't be dancing *every* dance, or talking *every* second. It was a weeknight and getting late. When the band began the first notes of "That Old Black Magic," I knew I wanted to leave. I could barely crack a smile.

Chapter Thirteen

When Mrs. Shuttleworth called about playing music with a friend of theirs, I couldn't wait. "I'll be right up," I told her.

Anything was better than sweltering in our steamy apartment, staring at the telephone. Jim had still not called, and the phone was a painful reminder of the times he'd answered the Checker Cab calls using dialects, leaving us in hysterics.

"I'm going up to the Shuttleworths'," I told Marty as I changed into a dirndl skirt. "They have a friend—some old guy who wants to play music." I had yet to play a cello for more than a few minutes all summer, a choice I knew I would pay dearly for all fall.

As I reached the top floor of the Seth Low in its

creaky caged elevator, a Chopin prelude filled the air, transporting me in just a few notes back to my parents' living room. It was the flashy B-flat Minor Prelude I knew so well—I could see my mother at our grand piano playing it after dinner, and I'd curl up on the couch to listen. Though that showy Chopin was very much the opposite of her demure manner, I'd beg her to perform it for my friends because I wanted them to see how talented she was.

I stood there, transfixed. This Shuttleworth friend sounded like a pro. What was I getting into? I waited for the last chord before I rang the doorbell.

"Oh, Marjorie." Mrs. Shuttleworth hastily ushered me in. "What an evening this will be—though I am so sorry that Mickey and Abby will miss it." I was amazed to see her dressed in a light-peach voile dress, a pearl choker, an organdy apron, and dots of rouge on her cheeks. The tantalizing aroma of gingerbread from their kitchen made my mouth water as I followed her down the long hallway.

"Is it someone's birthday?" I figured it must be a special occasion for her to be dressed to the hilt, wearing makeup and using sugar rations for a cake.

"Not at all." She smiled. "Wait till you meet our friend!"

Entering the large living room, I saw their guest silhouetted at the piano against the bank of windows overlooking Morningside Park. Mr. Shuttleworth rose from his chair. "This is Mr. Hugh Smith, Marjorie, an old friend of mine. He's on the music faculty at Yale."

Yale! I didn't hear anything else. Why hadn't I been warned? Why hadn't I been practicing? Mr. Smith, a slight man with thinning gray hair and bushy eyebrows, stood and removed his glasses as he patiently listened as Mrs. Shuttleworth rattled off my accomplishments. Was she intentionally confusing my mediocre talent with those of a brilliant virtuoso? I wanted to interrupt, "Enough, please—I'm only a *student!*" I was desperate to find some way to beg off.

"I'm looking forward to one of the cello sonatas," Mr. Smith said, sitting down again at the piano, rifling through a stack of music. "I'd far rather make music than go to a concert—even here in New York City."

Charming. Wait till he heard me—he'd wish he'd been at the Oscar Levant concert at Lewissohn Stadium. But everything had been set up: the carved wooden music rack by the piano, a straight-backed chair at the correct angle, a lamp nearby, and the cello beside the chair.

"Haven't heard that cello in ages," Mr. Shuttleworth said, refilling his pipe.

"I'm afraid I'm a bit rusty," I confessed, remembering my teacher's favorite adage: Miss one day of practice, you know it; miss two days, your teacher knows it, miss three days, *the whole world* knows it.

"I found some rosin for the bow," Mrs. Shuttleworth said, hovering nearby. "Do you have enough light?"

"Thanks—it's fine," I said, trying to sound convincing. I rosined the bow to stall for time, trying to slow things down. Still, strings could break, pegs slip, or, if I was lucky, I could faint into a heat-induced coma. But unlike in our scorching apartment, where it was possible to melt into a puddle, a cool breeze from the park sent the curtains billowing out behind us.

"So what shall it be?" Mr. Smith asked, playing a chord for me to tune. "There's Beethoven, Brahms, and *Breval*—the three Bs." We had a good laugh over that one—only cellists had heard of Breval.

"Which Brahms?" I perked up. "The E-minor?" He nodded. The Brahms was a different story—a sonata I might be able to bluff my way through, for I'd played it often with my mother.

"Tricky last movement with the fugue," Mr. Smith said, turning to the last page.

"Is it ever," I agreed, hoping that the piano might drown me out.

"Have you ever played this Brahms?" I asked Mrs. Shuttleworth.

"Yes, many years ago," she said, "but I've been so involved with the Girl Scouts and my volunteer work at the Riverside Church that I haven't touched the cello in some time."

"Would you like to turn pages for me?" Mr. Smith turned to her. "We'll want all the repeats."

All the repeats? Ohmygosh.

"Certainly—I'd love to," she said, moving to the other side of the piano.

"Shall we?" He looked at me, poised to begin. I nodded and tentatively began the opening theme, trying to coax a focused tone from this cello I'd never even touched. It wasn't until the recapitulation that I began to feel more comfortable, and the easier second movement flew by. We stopped for a moment to cool down, while Mrs. Shuttleworth excused herself and brought us glasses of iced lemonade. Refreshed, we dug into the fugue in the last movement. It was like a race. Good heavens, the tempo! I tried to keep up.

"I tried to stay with you." Mr. Smith laughed when we reached the last chord. "But that was a new mark!" And I'd thought *he* was the one pushing the tempo!

"How exciting!" Mrs. Shuttleworth said. "You'd think you two had played together forever."

Though my fingers were sore and tender, I felt elated. I'd forgotten how much I'd missed playing.

"Isn't it amazing, no matter how tired you are—music always gives you a lift," he said. I couldn't agree more. I knew, too, the magical feeling.

"We need to celebrate," Mr. Shuttleworth said, filling the wineglasses on the coffee table as we took seats across from him.

Mr. Smith raised his glass in a toast. "To Brahms!"

"To Brahms!" we echoed, though my hand was still trembling as I held the glass.

What a party! I couldn't keep my eyes off the frosted gingerbread cake on the crystal cake stand, or the *three* kinds of cheese, English crackers, and chilled Bordeaux their guest had brought. I hadn't seen a spread like that since I'd left home.

"Do you come from a musical family?" Mr. Smith asked, cutting himself a thick slice of cheese.

"Yes," I said, "I've been lucky. My sister's a violinist, my brother plays French horn, and my mother is a wonderful pianist. In fact, she played that Brahms with me."

He raised his eyebrows. "She plays that well? Where did she study?"

"She was at St. Olaf College and then transferred to Northwestern."

Whenever I thought of those schools, I had to smile. My parents had picked our names from their college yearbooks. When my sister and I were little, we'd argue over which girl was the prettiest, leaving finger-smudges all over their books.

"I know the schools—excellent music," he nodded. "And who's your teacher at Iowa U.?"

"He's from Germany—his name is Hans Koelbel—Piatigorsky was in his class when they studied with Klengel," I couldn't help bragging.

"We've inherited a lot of great artists from Europe," he said. "Stravinsky, Schoenberg—and then Bartók, who happens to be here in the hospital—very ill I'm afraid." Stopping to light a cigarette, he added, "You probably know that Hindemith is at Yale."

"*Paul Hindemith?*" I almost jumped out of my chair.

"Yes," he said. "Have you played his music?"

"Have I! I'm playing his unaccompanied cello suite for my next recital—"

"Really," he said, leaning forward. "Too bad you won't be at Yale to perform it."

I laughed. "Wouldn't that be funny—a girl at *Yale!*"

"We have girls at Yale," he said, looking at me, surprised. "The School of Music admits women." He

set his glass down, looking at me seriously. "As a matter of fact, you should apply for a scholarship. Yale needs talented cellists—I know for certain that you'd qualify."

A scholarship at Yale? I almost choked on my wine.

I sat there stunned as the Shuttleworths and Mr. Smith began talking about scholarships and the Yale music program.

"You'd be interested to know"—Mr. Smith turned to me—"Hindemith has organized a Collegium Musicum—students play Renaissance instruments like the viola da gamba."

"What an opportunity!" Mrs. Shuttleworth broke in. "And the timing couldn't be better." She sliced me another piece of gingerbread. "You can go from here directly to New Haven—just in time for the fall semester. Won't your parents be *thrilled*?"

"It's only six weeks away," Mr. Smith added.

My cheeks were blazing, my head reeling. Or was it the wine?

Mr. Shuttleworth refilled my glass. "Just think— you can graduate from Yale."

"Good for you—and for Yale," Mr. Smith agreed.

I returned to my apartment in a daze, I could think of nothing else. Except Jim.

106 Morningside Dr.

Dear Family,

I had an incredible evening—invited to the
Shuttleworths' to play sonatas. The pianist
teaches at Yale! We played the Brahms—luckily
Mrs. Shuttleworth had the music. The most
fascinating thing—Hindemith is teaching at Yale.
I almost fell over! Also, did you know that women
can enroll at the School of Music? Amazing what
I've learned since I've been here! You can imagine
what an exciting night I had there!

We're still planning to see a Yankee game,
Phil, and I haven't spent your five dollars—yet!
This Saturday, we're heading for the ocean.
We're so excited. The Shuttleworths wrote out
the directions—you have no idea what a great
help they've been!

Love, Marjorie

Hindemith—the Collegium Musicum—French Re-
naissance Music—the Ivy League—oh my!

The Shuttleworths have helped me beyond my
wildest dreams! They're as thrilled as I am about Yale.
Maybe there's life without a *boyfriend*!

My parents are going to be so proud. I can hear my

father, the dramatic way he makes announcements. And Mother's face will light up! The semester I stayed home to help after her surgery was an eye-opener—teaching her piano students for fifty cents a lesson and playing the church organ on a meager salary. Yet I never heard my mother complain. Not once.

Still, how can I tell them about running off to New Haven and *not* going back to Iowa U.? What will Mr. Koelbel think after all the concerts he arranged for me next semester?

It's the chance of a lifetime—but with so many strings attached. Why couldn't life ever be simple?

Chapter Fourteen

Mr. Hutchison, meticulously dressed with a gold watch chain across his vest, was explaining to Marty and me the history of the legendary Tiffany Diamond, mounted above him in a glass case. He said it had been discovered in Africa, in 1877, and the Tiffany Company sent it to Paris to be studied for a year before it was cut to the present 128.51 carats with ninety facets. "That's why it gleams like the sun," he explained. "The largest flawless, perfectly colored canary diamond ever mined!" As he continued the fascinating history, I heard a loud rap.

It was Mr. Judd at the watch counter.

Reluctantly, I left.

Although he could see I was hurrying, he rapped

again, looking grim. I was fond of Mr. Judd, who entertained us with colorful stories about famous customers like Al Jolson, Mrs. Rudyard Kipling, and Enrico Caruso. But today he seemed oddly aloof.

"Please take this watch to the repair room—it seems the second hand is not quite accurate." He glanced at the customer leaning against the counter. "This gentleman has a taxi waiting."

A taxi waiting? *This gentleman?* This character didn't look like he could afford a taxi ride around the block, let alone pay for one with the meter running. His snap-brim fedora hat was pulled to his eyebrows and he was stuffing a packet of tobacco into the pocket of a heavy, ill-fitting jacket. Strange customer.

I placed the Patek Philippe watch in my bag, surprised that it needed repair. These exceptional watches were accurate to the second with a reputation for having the finest mechanism in the world. Why would this guy care if it was one second off? But who was I to question? I rushed to the employees' elevator, and headed for the second floor. "This watch needs the second hand fixed immediately—the customer has a taxi waiting," I breathlessly informed the head repairman.

He nodded, though not impressed with the urgency, and gave it to the watch man inside. I peered

through the glass as he removed the back of the case and adjusted the loupe to his eye. I prayed it wouldn't take long.

How could that down-and-out customer own a Patek Philippe watch, I wondered. Maybe he was one of those miserly millionaires with wads of cash stashed under a mattress, or a messenger for a big-time celebrity. But I knew from Mr. Judd's anxious expression it was important to hurry.

I stared at the large clock on the wall and shifted my weight from one foot to the other, giving my left leg a rest, then the right. Time dragged like an endless Bruckner symphony. I peeked through the window at the repairman hunched over his worktable, then to the clock on the wall. The only sound was the echoing hum of the second hand as it clicked forward every notch. *Tk—tk—tk—tk,* like the repetitious slap of a rope on the sidewalk with the rhythm of the jump-rope chant:

RICH man, POOR Man, BEGGAR Man, THIEF
DOC-tor, LAW-yer, MER-chant, CHIEF!

I felt my heart beating faster and faster, as if I were jumping rope. How long could I keep up this left-right dance?

Suddenly, the watch man turned around, replaced the back of the case, wrapped the watch *painstakingly,* then moved with deliberate steps to the door and handed it to the head man, who in turn gave it to me. It seemed as if we were all trapped in a slow-motion movie.

With the watch safely in my bag, I thanked him, ran for the elevator, and concentrated on regaining my composure before reaching the main floor. The customer was still there, staring at the Tiffany Diamond. His hat drooped over his forehead as he slouched against the counter. *Please—at Tiffany we don't lean on counters!*

After Mr. Judd gave him the package, our scruffy customer shuffled out. The doorman assisted him through the Fifth Avenue entrance and we watched as he climbed into the taxi and sped away.

Mr. Judd leaned over the counter and said in a confidential tone, "That man is a notorious New York gangster. He goes by an alias, but his real name is like yours—Jacobson."

Holy moly! A gangster . . . with *my* name? Be still my heart. Forget "poor man." This one was a rich thief! I felt as if I'd just dodged a bullet.

"This gentleman would like you to model these earrings," Mr. Hutchison said, nodding to his customer.

Model? My favorite fantasy. In the last *Vogue* issue, Tiffany's pear-shaped diamond ear clips peeked out of a pink felt hat by Lilly Daché, worn by a gorgeous model. It made me gasp. I didn't have a hat, but I brushed my long hair back and lifted my chin high. I'd try my best.

I glanced at the attractive customer, though his dark hair was slicked back as if it was plastered on his head, a bit greasy. His bleary eyes darted about, making me feel uneasy. Hutchison was holding a pair of glittering diamond earrings in the graceful shape of a swan and showed me the delicate device in the back to secure them. I'd never worn earrings in my life.

While they watched, I gave them a *Vogue*-type smile, halfway between a smirk and a pout. I placed the earring on my right ear and secured it easily. For my left ear, I hesitated, unsure how to proceed.

Instinctively, I raised my right arm behind my head to reach my left ear. I caught a glimpse in the mirror of my elbow sticking straight up in the air. I looked like an orangutan in the zoo, scratching its back, and burst into a giggle. Gone was my refined *Vogue* smile.

The customer chuckled, too, exposing a row of yellowed teeth.

"Lovely diamonds," he said, turning his head to look at both, "interesting shape—but maybe you could match those blue eyes of hers with sapphires." Mr. Hutchison nodded to the salesman across the aisle, who brought a pair of stunning sapphires circled by small diamonds.

"I didn't know you had models," the customer mused, stepping closer to me. Mr. Hutchison explained that I was a girl from Iowa, filling in for their pages.

"Oh," he said, "one of those wholesome *Iowa* girls on their way to the big city."

Would you believe a wholesome Iowa girl on her way to Yale?

"Tell me," he asked, "do you ride bareback on horses in Iowa?"

"No, not yet." I almost laughed out loud.

"Have you ever been to a horse race?" he said, peering at me.

I tried a convincing smile. "I'm afraid I haven't had that opportunity."

"Pity—what a pity," he said. Then, turning to Mr. Hutchison, "Why don't we try—yes—those pearl earrings," he said, pointing to the counter.

Good grief! I have to go through this *again*? We weren't finished? It was just the beginning. After the

pearls, there were amethysts, then emeralds, and on to rubies. My face matched their color when I realized our esteemed customer wasn't looking at earrings. His gaze was definitely lower than my earlobes.

He was staring at my bust.

In the mirror, I saw how my bra lifted each time I reached my arm behind my head. He moved closer, so close I could see the red veins on his nose and the hairs in his nostrils.

Our customer wasn't talking about horses anymore. He'd moved on to nightclubs. Had I been to the Stork Club? Had I heard of Brenda Frazier and the other New York debutantes? Would I like to see that exclusive Cub Room? Actually, I'd have given my treasured eyelash curler to see it. Instead, I smiled demurely like a wholesome Iowa gal. But he was flirting. I knew flirting. Why wasn't he thinking of that dear one he was buying the earrings for, his mother, his wife, or his sweetheart, instead of giving me the eye?

By now a considerable number of salesmen were trying to assist Hutchison with their offerings of earrings. With an audience forming, my cheeks began to burn, my heart to thud. I had no skill at hiding embarrassment.

Please, please, make up your mind.

"Which pair do you like the best," he asked me, "the sapphires—or those lovely diamonds?"

"*The diamonds!*" I replied enthusiastically. "The swan shape—they're exceptional!" *And exceptionally expensive.*

"Yes—the diamonds are quite special," he said. I didn't dare move. He was now only a nose length away—we were eyeball to eyeball.

"*Very* special!" I squeaked out.

"Then it's decided," he said to Hutchison. Turning back to me, he winked. "Remember to be right here the next time, young lady."

As soon as he left, the salesmen crowded around. Did I know he was famous? Fabulously rich? New York's most eligible bachelor?

"I could tell he liked you," one of them said, "so the next time, try this. Begin by telling him the history of the Tiffany Diamond—ask about the horse races— and then the nightclubs, his stomping grounds. You never know what might happen!"

Who cared? All the coaching in the world would never sway me, even when they told me who he was. The famous playboy, Mr. Jimmy Donahue, heir to the Woolworth fortune.

106 Morningside Dr.

Dear Family,

Guess what?? There's a gangster here in New York with our name! He walked into Tiffany's for a watch repair—a horribly expensive watch—while a cab was waiting. When he left, I found out his name is *Jacobson*. I could have fainted—talk about embarrassing! Is there a skeleton in our closet I don't know about? Maybe it's Jacobs*en*—Norwegians AREN'T gangsters! That's New York City for you—they let hoodlums run around loose!

Tonight we're heading to an opera. Tickets are only a quarter at Lewissohn Stadium—a wonderful open-air theater. Though Carolyn will be with her boyfriend, our friends from Long Island are coming with us. More later.

Love, Marjorie

La Bohème! The characters were like us—starving artists in the garret. But the story was so sad; everybody cried at the end when Mimi died. Except me. I began sobbing in the third act during the snow scene when Rodolfo and Mimi broke up—and all the way to the end.

Back at our apartment, Sheila opened a Coke, lit a cigarette, pulled up the chenille chair, and crossed her legs.

"Guess what?" she said, raising her eyebrows. "Bet you don't know which Kappa went all the way?"

Did that get our attention! The girls flocked around like hummingbirds. "Who?" "Tell!"

"Can't tell—I promised," Sheila said, enjoying the dramatic silence. "But I can give you a hint—she's the last one you'd ever expect."

Immediately, we began yelling names, starting with the seniors down to the pledges.

"Not one of *my* pledges—I know." I'd been their pledge captain and I'd watched them like a hawk.

Someone yelled, "Marty!"

"No way . . . I'm as pure as the driven snow."

"Hey," Joannie said, "quit looking at me—Eric has been in the Pacific forever."

Anita laughed. "It's *not* me . . . but I know *how* you do it!"

Ohmygosh.

I looked at her, amazed.

"I asked my dad if it was this way"—Anita slapped her palms together vertically—"or this way." Now she slammed her hands together, right over left—horizontally.

"And *that's* the way—according to my father." Anita giggled.

Joannie was looking at Anita. "Bet that's not the only way," she said, slyly.

"How would you know?" Sheila accused Joannie.

Suddenly, my flushed face got attention that it didn't welcome.

"Marjorie!" Everyone shouted.

My blush turned to tears. "I don't even *have* a boyfriend," I confessed. "Not anymore."

After a gasp of silence, the girls chimed in, "You're kidding," "How could he?" "That creep!"

Our living room turned blue with smoke as everyone shared a horror story about being ditched, jilted, or left in the lurch. The wild stories went from juicy to lurid, until Joannie gave me a sympathetic look. "If he calls again—you just tell him you're calling it all off."

Like a stage cue, Sheila jumped up and snapped her fingers. "Yeah—'*You say eether and I say eyether—You say neether and I say nyther—*'" Everyone joined in. "*Eether, eyether, neether, nyther—Let's call the whole thing off!*"

Jumping up and forming a chorus line, we screamed the verses: "*You like potato and I like potahto—you like tomato and I like tomahto—Potato, potahto,*

tomato, tomahto—*LET'S CALL THE WHOLE THING OFF*—"

Nobody could kick higher than I could—did we have fun! I was delirious until everyone dropped from exhaustion and crawled into bed . . . except me.

I stared out our window for a long time, at that bleak brick wall where not a speck of sky could ever be seen.

Chapter Fifteen

Saturday morning, I was happily humming *"At the tables down at Mory's—"* as we rolled up our Jantzen swimsuits in a towel. We grabbed a bag of peanuts, and counted the money for the subway, the train, and two buses. It was an all-day trip. There was one agonizing moment on the subway when I thought I saw Jim—until his look-alike turned around.

The bus to the beach was so crowded we had to wait for the next one. People were laden down with umbrellas, picnic hampers, sand pails, blankets, and even inner tubes! With gas rationing no one dared use their stamps to drive a car simply for pleasure.

We finally arrived at Jones Beach in early afternoon.

Neither Marty nor I had ever dipped our toes in an ocean before, and we quickly saw what we had been missing. This was *heaven*, with white stretches of beach hot beneath our feet, gusts of cooling wind, and birds skimming close to the water. Breathing in that crisp, salty air, listening to the roar of the surf, I wondered why anyone lived anyplace else. And obviously, the throngs of sunbathers, with kids, picnic boxes, and beach umbrellas, felt the same way.

We laid out our towels close to water's edge, feeling so lucky that other bathers hadn't claimed this space.

Jumping through the waves was exhilarating—after the freezing shock of the first one. Each time, we ventured farther beyond the breakers, as fearless about this new adventure as we had been when we first boarded the train back in Iowa. But try as I might to actually swim, the ocean waves made things *a lot* different from swimming in Lake Comar!

Back on land, I wasn't sure whether it was the salty air or the lingering giddiness over modeling earrings for a millionaire that emboldened me, but the beach seemed spread out like a stage, and despite the fact I hadn't tried a handstand in years, I began cartwheeling across the sand, then walking on my hands. Then without warning, my arms began to cave, and my feet low-

ered into a backbend—my hands and feet holding me up in a bridge position. I was stuck. But aware that I'd attracted an audience—one little family—I was determined *not* to disappoint. I dug my feet into the sand, and kicked my feet back up into a brief handstand, before crashing into a kneeling position. I kept a big smile on my face, and they clapped for me regardless.

I picked myself up and stumbled into our towels. Marty was already asleep. Now that the family near us had gathered up their stuff and left, I found more room to stretch out. After I lay down, the last thing I remembered was the salty taste on my lips.

BOOM!

A giant wave crashed on top of us and all of a sudden we were being pulled into the ocean! Our pedal pushers, halters, towels, purses, and shoes, even our half-eaten bag of peanuts had already left us, bobbing along in the foaming surf. Stunned and now very awake, we dove into the water and tried to grab everything, hurrying back before the next wave could swallow us. As that wave receded, back into the water we went, retrieving what hadn't already sunk. When we dragged our sopping belongings up on dry sand, I froze.

Holy moly! What had happened? Where was everyone? Just a few minutes ago there'd been hundreds of sunbathers and swarms of kids everywhere. Now they were gone! It was eerie.

We were alone. How long had we been asleep?

With killer sunburns, Marty and I trudged to the bus stop in water-logged clothes and squeaky saddle shoes, with tangled hair, carrying dripping suits and towels. Two buses, a train, and a subway ahead of us. We waited interminably. *Where was that darn bus?*

It never arrived, but a shiny black police car screeched to a full stop.

"What are you girls waitin' for?" one of the policemen asked. Whimpering and sniffling, I couldn't explain. Marty pointed to the bus stop sign. "We're waiting—for the bus!" My cracked lips could scarcely form the words: "We're from Iowa . . . and we've never been . . . to a beach . . . before." The officers looked at each other and broke up laughing.

"The last Jones Beach bus leaves every day at five o'clock," one officer finally scolded. *The last one! He must be mistaken.* But then the officers took control. "Hop in—we'll take you to the next bus. And just remember—we got oceans with *tides*. You're not in Ioway anymore!"

106 Morningside Dr.

Dear Family,

We made it to the ocean—finally! It took us a couple of hours to get there, but it was worth it. So exciting to dive through the waves—you can't really swim in the ocean. But Phil, you'd love it. Right now we're covered with Unguentine that Mrs. S. gave us for our sunburns. Afraid we did get burned.

There are a lot of surprises when you're having fun in the sun!

Love, Marjorie

Lots of surprises . . . That night, when I entered the lobby in my musty, damp pedal pushers, my hair in my face, carrying my towel and bathing suit, I couldn't believe what I was seeing. Jim! Lounging in a lobby chair. I stared in silence, open-mouthed. Mortified!

"Hi!" Jim said. "Been to the beach?"

Have *we* been to the beach? Where have *you* been?

I croaked out a "Hi," or something like it.

Marty sent me an eye-roll and was on her way to the elevator, while I stood there not knowing whether to be mad or to cry.

Jim knew something wasn't right.

"You didn't get my message last week, did you?" *Had it been only a week?* "That I'd see you this Saturday?"

"No." My voice wobbled. I could scarcely talk; my lips were cracked, and my face stiff from the sunburn. I suddenly realized how Jim was seeing me—how he could even recognize me! I was humiliated. "I'm sorry," I said, my eyes smarting, "I didn't get any message."

"We were moving back to John Jay Hall from the Hudson River—I called a couple of times and left a message." He looked pointedly over at the desk clerk. "I hope you didn't think I'd stood you up. Did you?"

I shook my head—better than lying out loud.

"Tell you what, kiddo, I have next Saturday off. I feel terrible that you didn't hear, but right now you need to take care of that sunburn. Okay?"

"Okay," I said, wanting to smile through lips that couldn't move. He still wanted to go out with me after seeing me like *this*?

He waved goodbye and I limped to the elevator. It was amazing how one guy could take away so much pain. He's back! He's back! *Ohmygosh.*

Chapter Sixteen

Monday morning, the secretary stopped me on the way from our locker. "Mr. Wilson is looking for you," she said, "he's in his office now."

Oh boy! The door was open. Now what? Hesitantly, I asked, "Mr. Wilson—sir?"

"Miss Jacobson—I need to tell you about a change," he said, brushing off a tiny thread from his lapel. "Our third-floor supervisor is requesting help—would you like to be assigned there?"

"Yes, sir," I exclaimed, with relief. Though I'd only had a glimpse, I knew the third floor was a fantasy-land of glistening crystal stemware, English flowered tea sets, gold-rimmed china, and gigantic ornate vases.

Enviously, I had watched mothers and daughters taking the elevator to the second floor for their silver patterns and to the third for their china and crystal, or waiting standing in line at the Bride's Register.

Mr. Wilson jotted my name on his memo pad. "Good enough—so after your lunch hour the supervisor will be expecting you."

When I told Mrs. Ross, the nurse, she cried, "I could spend *hours* on that third floor! Just wait till you meet Mr. T.C.!"

"Mr. T.C.?" I asked. Did I hear right?

"That's what we call him. The secretary jokes that it stands for tall and cute! She has quite the crush on him," she added, raising an eyebrow.

"But Marjorie"—she pulled me aside—"what happened to you this weekend—the beach?" she prompted. "Try some of this; you'll feel better." She reached for a salve. Whether it was blisters, burns, or a broken heart, Mrs. Ross always knew just what to do.

When I told Marty, at lunchtime, she laughed. "Those old gals would go into a swoon for anybody in pants."

"I know—like that Andrew Sisters song, " *'They're either too young or too old—they're either too gray or too grassy green'!* Those salesmen are old enough to

be our grandfathers! And I'm certainly not going to call that supervisor by his initials!"

When I took the elevator to the third floor, an imposing gentleman with deep blue eyes and a shock of sandy hair strode over to shake my hand.

"I'm Theodore Louis Cassidy," he said, towering over me, "but just call me Mr. T.C. We want to welcome you to the third floor, Miss *Marjorie.*"

Miss Marjorie? *Wow!* With his resonant bass voice, my plain name rang out like a heroine's in an English novel. I could barely speak.

After introducing me to the salesmen, he smiled. "Now for a tour, Miss Marjorie!"

"First, we'll look at the model table settings," he announced as we marched to the front of the floor near the lustrous and tall windows overlooking Fifth Avenue.

"This one has the blue Wedgwood pattern," he said, showing me the colorful china on a sleek blond table with curved-back chairs and a sidebar for cocktails.

"And this one," he said as we sauntered to the alcove on the opposite side of the room, "has our traditional setting—Royal Doulton's Old Leeds Spray for the Sheraton table." I caught my breath—my family's best

china! It was arranged on the table with a wide array of crystal glasses and silver flatware, and a graceful silver candelabrum. Around the table were eight mahogany chairs with a handsome breakfront by the wall.

"Which would you prefer, Miss Marjorie?"

"The Sheraton table is particularly lovely," I said, not able to tell him that the colorful hexagonal plates and cups conjured up wonderful memories for me. "It has a special . . . *éclat,*" I said.

"And this fork"—he chuckled, picking one up—"is only for oysters—*n'est-ce pas?*"

I knew now why everyone was crazy about him.

I treaded gingerly beside Mr. T.C. as we continued the tour, and he pointed out the gold-rimmed Minton china, crystal stemware for cordials, toasting champagne flutes (*flutes?*), cups and porringers for children, and at the end of the counters, stunning ornate vases enclosed in glass cases. I was dazzled. We had only covered part of the floor when the chime of the elevator startled me. So much to learn, but one thing was obvious. Everything was fragile, delicate—and *breakable*!

Stepping out of the elevator was a formidable robust lady, wearing a white straw hat with a large speckled pheasant feather. With long strides, Mr. T.C. hurried across the floor to welcome her.

"Mrs. Robert *Rutherford*," I heard him say as he swooped down to greet her, "*lovely* to see you this morning." Her face turned pink as they chatted and with tiny steps she followed him to a counter of cocktail glasses.

"So much work now," I heard her sigh as the long feather from her hat swayed back and forth. "We have to be ready for the fall round of parties—left Maine early, you know. Now with the war finally drawing to an end—it does look like it will end, doesn't it?" She seemed to be waiting for a definite answer.

"Indeed, Mrs. Rutherford; we're all hoping so," he said to reassure her. They commiserated as they examined the champagne flutes. She held up one glass after another, rotating each stem to catch the light, tilting her head, as she continued to chatter about her rigorous summer in Maine.

After that recital, Mr. T.C. brought her over to meet me.

"Mrs. Rutherford," he said, congenially, "may I introduce Miss Marjorie, our new girl. She'll be in charge of your champagne glasses for the shipping room."

I smiled. My lowly page job had just been raised a notch.

"Oh, my goodness—how *lovely* to have you here,"

she gushed. "Now please tell me—where is it that you're from?"

"I'm from Iowa," I said, flustered by the attention.

"Oh, my *dear*!" She shook her head, her feather bobbing. "Here on the East Coast—we pronounce it O-hi-o!"

I bit my lip. Mr. T.C. winked. A conspiratorial wink. Besides the wild "Iowa-ho-ha" lines the Easterners fed us, now we weren't even on the map! Wait till Marty hears this one. She had vowed that the next time Iowa was put down, she'd say, "Do you know which state has the highest literacy rate?" We had a heyday dreaming up comebacks.

On my way to the elevator with my box of champagne flutes, I felt giddy, as if I was entering a new stage in my life. Now, working on the third floor with the distinguished Mr. T.C., becoming an Easterner, and soon to be a student at Yale, I had grown up. I had changed. Engrossed in my newfound status, my chin high, I marched confidently to the elevator—and bumped smack into Mrs. Ross, the nurse.

She caught me as my high heel slid, and Kevin, the elevator operator, yelled, "Hey, goil," as the box fell to the floor. Quickly, he reached to cushion my fall. *Horrors!*

My new job gone before it had started!

Mrs. Ross said, "I'm so *sorry*—my fault—too much of a hurry!"

"Not your fault at *all* . . . I wasn't paying attention." My eyes teared as I sat on the floor and reached for the box of champagne glasses, expecting to hear the clatter of broken glass. Quaking, I lifted the lid. We gaped. Like little Kewpie dolls, the champagne glasses were nestled neatly in their white tissues, untouched. They hadn't moved. For seconds I was motionless, trying to catch my breath, my chest heaving. I looked up as Mrs. Ross and Kevin helped me to my feet.

"Are you all right?" she asked, steadying me.

An overwhelming feeling of relief spread over me as I thanked them, *profusely!* They had saved me from landing on that box of priceless glasses. From now on, I promised myself, no more daydreaming. I needed to get a *grip!*

At lunchtime, I dashed to the locker room, anxious to tell Marty the latest. She wasn't there—it was after twelve. Disappointed, I changed into my sleeveless dress and went to the main floor to find out what had held her up. Was there a celebrity getting the attention?

The center of attention on the main floor was Marty.

At the front counter facing the Fifth Avenue entrance, salesmen were circled about her. Holding out her left hand, she was modeling a brilliant solitaire.

"I'm engaged!" Marty exclaimed. Like the glamorous model in the magazine ad: *She's engaged, She's lovely, She uses Pond's.* With her beautiful, long, slender fingers, the diamond looked fabulous on her fourth finger. Marty had a way of lightly tapping her cigarette over an ashtray like Rita Hayworth. It was enough to make you want to take up smoking.

The front-counter salesman beamed with pleasure. "That diamond is worth fifty thousand dollars," he said to me casually, as if it were pocket change. *Fifty thousand for just a ring?*

"So, if you'll excuse me," Marty said, as she rolled her eyes, "I need time to think it over—will let you know after lunch." We laughed.

But when she tried to remove it, the ring wouldn't budge. She stared at her finger. "I didn't have any trouble putting it on." She turned to the salesman.

"No problem," he said as he reached under the counter and brought out a tube of ointment. "We're prepared for this."

After rubbing the slick ointment on, she turned the ring back and forth but was unable to twist it past

her knuckle. She sent me an anxious look. I started to run for the nurse, but remembered she had left for the day.

Mr. Hutchison left his counter to bring a small bottle of lotion. After examining her finger, he advised the salesman to let Marty rest her hand. "I think her finger's a little swollen," he said. He was right. Her finger had reddened. The small cluster of salesmen began to kill time recalling similar incidents, and one joked about sending an armed guard with us to the Automat. I could see from Marty's face it was nothing to joke about. She looked desperate.

After a brief rest, Marty tried again. Beads of perspiration broke out on her forehead and the salesman began to stutter as he gave her advice. I felt sorry for her, with everyone staring while she was frantically trying her best.

Exasperated, Marty exclaimed, "I *know* how I could get it off—let me go to the ladies' room and run cold water over my hand. I'm *sure* I could remove it with soap and water."

Leave the counter with a fifty-thousand-dollar ring? They shook their heads. But I could see from the grimace on Marty's face, she was in pain. Those salesmen with all their lotions, ointments, and advice were of no help.

For an hour, after alternating between resting and trying to take off the ring, Marty clenched her teeth. "One more time—" I held my breath.

She rotated the ring back and forth, stopping and starting, until she finally closed her eyes and pulled it—*forced* it—over her swollen knuckle. When it slipped off, the salesman audibly sighed. Marty's eyes were almost brimming with tears.

"I've *never* felt anything so painful," she confided afterward, wrapping her hand in a handkerchief. "And I'm *never* putting a ring on that finger again—not until I *am* engaged!"

106 Morningside Dr.

Dear Family,

Everyone here is wondering when the war will end. I miss Eric Sevareid's broadcasts—feel so cut off without the radio. Isn't he related to the Sevareids in Story City?

Yesterday: I began working on the third floor— I love it! Wish you could see our china pattern displayed on their beautiful model table. I'll soon be an expert on crystal and china. Lots to learn in this city.

Love, Marjorie

"Lordy—what *was* that?" Carolyn exclaimed, jumping up in the dark when we heard the crash on the floor. I stuffed a pillow over my mouth to muffle my laughter; I knew exactly what *that* was. It was Marty, her midshipman, and the studio couch!

Our dark brown, armless upholstered couch, which had come with three unattached overstuffed pillows, enjoyed a life of its own and called for great respect. If you dared to sit near those pillows and lean against the wall, the couch would skate across the room on the hardwood floor, as if it were heading for the Hudson River. The ride was a merry one, until you fell on the floor.

"I felt sorry for this guy," she told us later. "I asked him if he'd like something to eat. 'You betcha,' he said. When I brought him a bowl of our lime Jell-O—it was the only thing in our refrigerator—he made a lunge for me. I leaned against the pillows to give the couch a start—and away we went! We landed on the floor, green Jell-O and all."

"Bet we won't be seeing him soon again." I laughed.

Thank heavens—besides being a girl's best friend, that couch had talent. It could skate on four wheels, careen on three, and with a good push—you'd have the Ride of the Valkyries! We should've nicknamed her Brunhilde.

Chapter Seventeen

It was a fierce downpour. Marty and I leaped over puddles to reach the employees' entrance as the rain streamed off my umbrella and trickled down my neck.

"We're in for it now!" Mr. T.C. said when I reached the third floor and watched the rain pound against the Fifth Avenue windows.

"Exciting, isn't it?" I said. The ends of my hair were wet, my rayon hose were baggy, and my patent-leather pumps squeaked "miss you—miss you," with every step. It didn't matter—thunderstorms were romantic. On one of our first dates, Jim and I had run for shelter in a downpour, and ducked into a porch, half-drenched. How exhilarating that had been!

Watching the traffic snarl on Fifth Avenue, lost in

my thoughts, I didn't hear Mr. T.C. call the first time. *Ohmygosh*, he was waiting for me.

"I've something to show you," he said, holding a bell-shaped decanter filled with an amber liquid. "My customer told me if we could remove the glass stopper of his heirloom decanter, the brandy was ours! So, Miss Marjorie—how would you like a lesson in brandy sniffing?"

Didn't he mean sipping?

"You'll find out what it's all about," he said, leading me to the Sheraton table with the other salesmen. "No one will be up here this morning—not in this kind of weather."

With that soaking rain and streaks of lightning, who *would* be out?

He drew a chair out for me facing the window; the two salesmen had seated themselves across the table, and Mr. T.C. went over to the breakfront. He carried back four glasses as large as fish bowls, on a silver tray. Wow—how much brandy would we be drinking? I tried to act nonchalant. Didn't I do this every day—sit at a handsome table with gold-rimmed Minton china, three different kinds of wineglasses, crystal candelabra, and silver napkin rings in the same pattern as the Tiffany sterling flatware, and polish off a brandy or two? Ha!

Humming a little tune, Mr. T.C. ceremoniously dribbled a little brandy into each glass and passed them around.

"First," he instructed me, "hold the snifter like this—rest it in the palm of your hand and cradle the bottom. That's to warm the brandy," he emphasized. I watched him as he lifted his glass to the light, then lowered it, turning the snifter gently to drive a thin layer up the sides, then made a wide circle and brought it under his nose—and *sniffed*. Was he serious? It wouldn't be the first time I'd fallen for one his jokes.

Being a good sport, I followed his example and self-consciously made a circle, waiting for them to laugh. Instead, they watched me critically and gave me pointers. I was petrified I'd accidentally knock over the crystal glasses in front of me.

Mr. T.C. leaped up. "Just a minute—we need more elbow room here," and he moved the wineglasses toward the center of the table.

"Now," he said, demonstrating again, "swing it in a *wide* circle so it will ventilate—then inhale the bouquet."

If this was an act, it was a good one, for he was as serious as the superintendent. At first, it felt awkward, but after a few swirls I learned to make a dip and then

a wider circle. Keep a steady rhythm, I told myself, so the brandy would whoosh around evenly. The others were swinging their glasses like cowboys with a lariat. Who knew, this could have been an eastern practice, a Four Hundred custom, or an essential ritual at Yale. The pungent aroma of brandy was tantalizing as we swirled and sniffed; all that was needed was a violin playing Kreisler in three-quarter time.

The morning evolved into a festive party and I soon became light-headed. First names were bandied about, store gossip was revealed, and jokes, funny or not, were greeted with hilarity.

"You almost have it now," Mr. T.C. told me. "Watch William over there—I'll bet he sniffs brandy every night when he goes home."

"You bet," said William, a straightlaced sort of fellow. "The kids and I head for the library and bring out the snifters as soon as they're home from school."

I giggled and they began laughing; William laughed till tears ran down his cheeks. The more I tried to contain myself, the more I giggled, and Mr. T.C.'s rippling bass laugh made us howl. Golly—the fun we were having! That brandy!

I had looked out to see if it was still raining when we heard the chime of the elevator bell. Mr. T.C. stood up abruptly. Without a word, he reached for my glass

and walked away. Both salesmen jumped up, quickly placing their glasses on a shelf in the breakfront, and left me sitting there, dumbfounded.

I turned around toward the elevator.

Holy Toledo! It was Old Man Tiffany!

What was he doing here in this weather?

But there was our vice president, in full raingear regalia. I knew he had a reputation for surprise visits—the shipping clerk had alerted me.

"Have you seen Old Man Tiffany yit?" he had asked one day.

"I don't think so—what does he look like?"

"Oh, you'll know 'im all right—when he shows up."

I found out what he meant one afternoon, when a dead silence spread through the main floor, like a fog rolling in. The only sound was the superintendent clearing his throat. A fastidiously dressed, slightly built, white-haired gentleman strolled through the Fifth Avenue entrance; the salesmen stood at attention as if they were at a military inspection. He made a tour of the main floor, scrutinizing the jewelry at each counter, tapping the glass to indicate a slight change: the diamond bracelet—half-an-inch over; a gold cigarette case—to the right; or please—replace the emerald brooch with the ruby and diamond necklace. The gentleman with the radar eyes was Mr. Charles Lewis Tiffany II, son

of Louis Comfort Tiffany, grandson of Charles Lewis Tiffany, and the great-grandson of Comfort Tiffany.

Now I stood transfixed, and afraid to breathe.

"Good morning, Mr. Tiffany," Mr. T.C. greeted him in his jovial manner. "May I take your umbrella and coat, sir? A bit of rain we're having."

The old gentleman was wearing a vivid red-and-black tie in a Picasso design, anchored by a shiny gold stickpin. Mr. T.C. stooped over to admire it. "Wonderful tie to brighten up this day, Mr. Tiffany," he said in his rich, deep voice.

The old man smiled.

The two of them chatted as if they were poker buddies sharing the latest gossip. I looked for a place to hide. The only tall object was the large oriental vase in a glass-enclosed stand. Nothing to snuggle up to, but I stood motionless as a mummy. Furtively, I glanced back at the Sheraton table. It was in shambles. The crystal glasses were scattered all over, my chair stuck out at an awkward angle, and heaven only knows where my snifter with the telltale lipstick smear had landed. I looked at William, who had fear written all over his face. If he was scared, what about me? I couldn't have been more terrified if I'd been stranded on a subway platform after midnight.

From the corner of my eye, I saw Old Man Tiffany looking at a crystal punch bowl, then suddenly he began walking to the contemporary model table. Oh, no! I held my breath. I could only hope that he'd hold his as well, for the distinct aroma of brandy was still lingering in the air. Was it true that people lost their sense of smell with age? "What do you think of this arrangement with the Spode luncheon set?" Mr. T.C. inquired in his suave manner. "We're in the middle of *rearranging* these tables."

Quick thinking, Mr. T.C.

Mr. Tiffany studied the streamlined American Deco silver flatware with the luncheon plates. The plates were unusual; the rims were scalloped in a thin soft green and each one had a different flower in the center. After exchanging the wild rose plate for the one of the daffodil, he nodded his approval.

"And you remember at the old store," Mr. T.C. went on, "the time Mrs. Morgan couldn't decide between the Royal Crown Derby and the Wedgwood for her luncheon?"

"And ordered a hundred settings of each?" Mr. Tiffany added with a smile.

Hearing a loud clap of thunder, they remarked on the miserable weather and started to reminisce. One

story caused Mr. Tiffany to wag his finger and laugh. I began to breathe normally again as the two of them relived the good old days and began to walk toward the elevator.

Next—oh, no—they turned, heading in my direction. I shivered and braced myself. Did he know that I was one of the new pages? They lingered beside the Minton china as Mr. T.C. picked up a huge gold-rimmed soup tureen. The tureen that cost the price of a Ford!

What if he dropped it? What a wicked thought. I was hyperventilating by the time Mr. T.C. had placed it safely in its niche and the elevator bell chimed. Mr. Tiffany looked startled as a lone customer entered. He muttered a few words and headed for the elevator, his hands clasped behind his back. My hands were white; I'd gripped them so tightly.

While William took charge of the new customer, Mr. T.C. retrieved Mr. Tiffany's coat and umbrella. That was the last time I saw the old gentleman. Mr. Tiffany tossed his raincoat over his shoulder in a rakish manner, waved his umbrella from the elevator, and grinned mischievously—as if he was a young again, and ready to speed away in his stutz Bearcat roadster to join the Roaring Twenties crowd.

I sighed. If only Mr. Tiffany had joined us at our brandy sniffing party, he could have been the grand-master of them all. I could never call him "*Old Man Tiffany*" again.

106 Morningside Dr.

Dear Family,

There have been a few surprises lately. Mr. Charles Tiffany, our vice president, showed up on our third floor! You can imagine the excitement to see a real Tiffany. He's a small man, and dresses very smartly. He reminds me of Rev. Scarvie, impressive and stately. We're on pins and needles when he's around, because he likes to inspect everything—and there's never any warning when he'll show up. However, he did seem to enjoy his tour around our third floor.

No, I didn't talk to him, but he did smile.

Have a date tonight with Jim—so have to get ready.

Love, Marjorie

I was so panicked when I heard the doorbell, I froze. There was Jim—with his droll smile and twinkling brown eyes, handing me a white box—a gardenia with green and peach ribbons. He'd said we'd be heading

for someplace special—the Claremont Inn more than likely. Was I dressed for it? As he pinned the corsage on my shoulder, he said, "You'll love this place down by the El—a place where you sing and pound the tables!" The way Jim wrinkled his nose and smiled, I knew it would be fun. Forget the Claremont.

At the corner of Third and Seventeenth Street, we could hear "On Wisconsin!" and smell the cooked cabbage before entering the door. The sign read: THE FRATERNITY HOUSE. "But we call it the GA Club," Jim said, "because it has wonderful German food and beer." I instantly fell in love with the red-and-white-checkered tablecloths, the round tables, and the dark-paneled wall with signed photographs, pinup girls, and memorabilia. A midshipman waved to us from a table, shouting, "Over here!" We joined the table with two other midshipmen and their dates, one girl with a gardenia in her hair. These midshipmen! It was like being back at college, singing every song we knew—fight songs, fraternity songs, state songs, from "On Iowa!" to *"Ninety-nine bottles of beer on the wall—Take one down and pass it along."*

We were still singing on Third Avenue as we headed back to Morningside Drive. That night, Jim's good-night kiss made up for lost time. Back together again.

Chapter Eighteen

We were besieged with war news. Black headlines every day and newsboys screaming on many corners.

On August 6, 1945, the first atomic bomb was dropped on Hiroshima, Japan.

The three-line-headline from the *New York Times* the next day proclaimed:

FIRST ATOMIC BOMB DROPPED ON JAPAN;

MISSILE WAS EQUAL TO 20,000 TONS

OF TNT; TRUMAN WARNS FOE OF A

"RAIN OF RUIN"

On August 8 the Soviets declared war on Japan and invaded Manchuria. The very next day the second atomic bomb was dropped on Nagasaki, Japan.

What would come next? When would the Japanese surrender? Surely President Truman would announce the end of the war any day. It was all anyone talked about, on the street, at the Automat, and around the Tiffany counters.

Like the European war, the Pacific war brought tremendous losses; everyone I knew had been affected.

I was afraid to open letters from home for fear of terrible news. Seven of my cousins were in the navy, one in the army, and another was a marine dive-bomber pilot. It was a constant worry. Story City had never heard so many church bells, tolling for boys we'd watched on the football field, the basketball court, and swimming at Lake Comar. And I knew the end of the war would not bring back my cousin Paul Donhowe.

Paul had died on November 5, 1943.

I'd stayed home that semester to help my mother after her surgery, easily stepping back into the familiar rhythm that regulated life in a small town. The twelve o'clock whistle downtown meant everyone would be home for dinner; noontime was the important family meal. The six o'clock whistle signaled the stores to be

closed and the nine o'clock was the curfew. Together with the ringing of the school and church bells, I never needed a wristwatch at home.

That chilly November day, after the noon whistle, I heard my father climbing the porch steps. "You're home early," I called when he opened the door. I scrambled to set an extra plate at the breakfast nook—Phil was already home from school. I loved the coziness of the nook, with so few of us why use the dining room? He usually stopped at the post office for mail from Katherine, who was completing a dietician's internship at a Cleveland hospital. That morning my mother and I had shared a good laugh about a recent note from Katherine in which she told the story about a young doctor who had been asked by a new mother to help name her twins. "Homogeneous and Heterogeneous," he'd suggested. Explaining this joke to my younger brother, we laughed even harder.

I looked down the hall, puzzled. My dad had stopped in the hall, his hand resting on the oak stair banister. One look at his solemn face and I knew something was wrong. "We have to go to Olive and Peter's," he'd said, his voice cracking as he went to talk to my mother. "Paul's missing in action. He was in a midair collision—parachuted from his plane. . . . Last seen

in his life jacket in the ocean," he told my brother and me.

On that cold day, Dad and I walked to my aunt and uncle's home. As we climbed the steps, I thought of how proud my uncle was of their hill, the highest one in town. "The architect ordered three gradings to get it right," he'd said. Everyone knew that hill for sledding in the winter, when my aunt served hot cocoa and gingersnap cookies afterward, or how the boys mowed it with their pony in the summer. The wide steps curved to the front porch. That day, I didn't want to reach the last one.

On the glass-paned front door were the familiar five blue stars, one for each boy. Would one of those blue stars become gold? I wiped my eyes on the wool of my coat collar to soak up the tears. Paul and his girlfriend, a WAVE he had met at the navy base in Jacksonville, had just been home, and every head in church had turned to admire that good-looking pair in uniform. And I remembered his next assignment: "Paul's been ordered to Seattle for the navy's fighter squadron," Uncle Peter had said.

We entered the house without knocking. It was painfully quiet. Not like the old days when all their children, six sons and a daughter, were home. No

scuffling or running, no one cranking the ice cream maker in the kitchen, no one to hide me in the cedar chest upstairs. From the oak-paneled hallway I could see my aunt Olive beyond the dining room, staring out of the kitchen window at the bare branches of the trees. Uncle Peter was silent in his chair by the fireplace in the living room. His head was bowed. Above his chair was a map of the world with five thumbtacks, indicating the countries where each of his sons served. Paul, who was seven years older than me, had been like a big brother, with charisma, before I knew what the word meant. It was Paul who would make us laugh and do anything to bring smiles to our faces. "Imitate Mae West," we'd beg, and he'd grab a dish towel and sashay back and forth, mimicking her sultry voice, "C'mon up and see me sometime." Even Great-aunt Margretha had laughed. It was Paul who was thoughtful, who was mature for his age. His last last letter, dated October 27 from a Fleet P.O. in San Francisco, was still in our breakfast nook. In part it read: "I certainly want to thank you for the enjoyable time I had at your home—it was really a surprise and carried an atmosphere of Christmas. A long time since I had eaten a dinner of lutefisk, lefse, and potato cakes—"

In other letters to our family Paul wrote, "I am enclosing a matchbox for Phil that he might not have—bet he's sorry to see summer over—at least I was when I was a kid," or to my dad, "how's the golf game coming—I certainly miss playing with you" or "what a surprise to find a dollar bill in every pocket—thanks a million" or "I like my assignment just fine. Without a doubt we have one of the finest airplanes built for that purpose—a terrific piece of machinery."

Now there was nothing but sadness in the house, and I had never felt so helpless. I stood in the living room, not knowing what to do. I whispered to my dad, "What can I say?" He told me to give my aunt and uncle a kiss; we were all beyond words. When I kissed their cheeks, their eyes were filled with tears. So were mine.

My aunt Olive had the painful task of writing the boys when the commander notified them that Paul had drowned almost immediately in the frigid water. Neither the military nor the Red Cross would grant a leave for any of the brothers—except for Herbert, a lieutenant in the navy—to attend Paul's memorial service. The funeral service would be held in St. Petri, and I was to play the pipe organ for my mother, who instructed me on what to do. "The recessional should

be 'America,'" she said. "Pull out all the stops." I knew I could play the selections, but I worried about keeping my composure.

From the organ bench, I could see that every seat was taken, and there was Mr. Jorstad, the church janitor, waiting to ring the bell once again. In his later years, he could barely reach the thick knot on the end of the rope, but no one understood that bell as he did, when to ring it before the resonance would fade.

I cherished this saintly man for his talent as an artist. He drew stunning birds in black pencil on the flyleafs of maybe a hundred small black hymnals, creatures with long, sharp beaks, fat bellies, and feathers that swooped as if they would fly off the page at any moment. His drawings had been my entertainment during long Sunday sermons when I was little. I reached for one of the old hymnals that day, tracing the bird with my finger once again and wanting to keep my mind on anything but this tragedy. After we heard "Taps," I played "America" with the organ's pipes wide open; the volume carried all the way downtown. And as my aunt and uncle and the rest of the family filed out, Mr. Jorstad began to ring the bell. I had never heard our church bell sound so mournful. I could no longer hold back the tears.

106 Morningside Dr.

Dear Family,

We're waiting to hear the news about the
Japanese surrender—Marty and I will be at
Times Square, you can be sure. I keep thinking
of that Sunday we had dinner at the Thompsons'
and heard the news of Pearl Harbor over the
radio. Do you remember when Maude said,
"I'm glad that Phil and Bruce are only twelve
years old." That seems so long ago—but our
family has been luckier than most.

Love, Marjorie

Our family was much luckier than most. But life was
never the same after Pearl Harbor. The next day, our
school principal brought in his Zenith radio for Presi-
dent Roosevelt's address: "Yesterday, December 7,
1941—a date which will live in infamy . . ." The boys
in my class were already talking about "joining up." By
the next summer, most of them had enlisted, my cous-
ins as well.

Less than five months after cousin Paul's accident,
in the spring of 1944, Lieutenant Richard Munsen,
Katherine's high school boyfriend with whom she still
traded letters, was reported missing in action. When

his father received the Western Union telegram from the Secretary of War, the news had circulated through Story City by the twelve noon whistle.

The telegram read:

WASHINGTON DC 8 PM APRIL 12TH 1944
SERRAL MUNSEN
STORY CITY IOWA

THE SECRETARY OF WAR DESIRES ME TO EXPRESS HIS DEEP REGRET THAT YOUR SON FIRST LIEUTENANT RICHARD S MUNSEN HAS BEEN REPORTED MISSING IN ACTION SINCE EIGHTEEN MARCH OVER ITALY PERIOD LETTER FOLLOWS

DUNLOP ACTING THE ADJ GENERAL 8:45 AM

The very next day, in the *Story City Herald,* a story ran with two large black-and-white photos captioned "AS WE REMEMBER THEM BEST, MISSING IN ACTION." The photos were of Lieutenant Richard Munsen and Lieutenant Colonel Hubert Egnes.

Mother wrote Katherine that same day—long-distance calls were very expensive and hardly ever made. Dick had joined the Army Air Force, become a pilot, and been assigned to the Fifteenth Air Force

in Italy. He had written Katherine, "I've flown 22 missions before my 22nd birthday!"

After the telegram and confirmation letter, the Munsen family didn't receive another word of news until Mother's Day, 1944. That's when Dick called home, the minute he arrived in New York City. "My mother almost had a heart attack when she heard my voice," he would recount many times. The family did not receive the army's telegram about his safety—or Dick's cable from Casablanca saying the same thing—until he reached home.

What an extraordinary story of survival he had to tell.

On March 18, 1944, almost a full month before the telegram had arrived in Story City, a German fighter plane had shot off the right wing of Dick's plane. A piece of shrapnel had cut his right arm. "I put the plane on automatic pilot and called over the intercom, 'Pilot to crew: Bail out! Bail out!' After all nine of my crew had bailed, I stepped down to the catwalk by the bomb bay. . . . Abandoning the plane I counted to ten, then reached with my right hand to pull the ripcord. It wasn't there. Panic-stricken, I reached on my left side. Saying a prayer, I found it and pulled the cord." In his haste he had strapped his parachute on upside down.

The crew landed in the mountains of Yugoslavia, and for forty-five days the men were hunted by Germans, finally being rescued thanks to the aid of Tito's underground Partisans, who had their headquarters in a cave. After a makeshift airstrip had been lit with burning oil-soaked rags, an American pilot made a night landing with his C-47.

Months later, when Katherine had finished her internship in Ohio, she took the train back to Story City, stopping along the way to visit me briefly at the University of Iowa. Katherine was relieved that Dick was safe, but there was no hint of a big romance and she had not seen him in almost two years. My sister was focused mostly on her plan to join the army as a dietitian. When she got back on the train, she had no idea that Dick would be waiting for her when she finally arrived home.

My father called me at school the very next day with the stunning news. "Katherine's getting married—come home for the wedding!" Dick had not only met the train but proposed in the car on the way home.

When I got off the telephone, I ran screaming to share the news with my friends who had met her just the day before. I had had no idea that Dick and Katherine were serious—they were always with their group

of high school friends, but on a special date the two had seen *Gone With the Wind.* I was ecstatic. This felt more like a scene from a movie than real life. Would something this exciting, this romantic ever happen to me?

Twelve days later, on September 17, 1944, the church was filled with gladioli from Magne Idse's carefully nurtured field of flowers, and Ilza, a violinist from Ames who had once been Katherine's violin teacher, was the soloist. I was the maid of honor, and Dick's sister Helen was a bridesmaid. Dick's brother and cousins were attendants, and my brother, Phil, was a junior usher. Although the bride stole the show with an elegant, shimmering white satin gown and train, no one ever forgot my mother's gown, found in Des Moines and quite the shock for traditional Story City: a striking black sheath sprinkled with tiny silver sequins.

After so much sadness, it was a glorious day. As my great-aunt Margretha said, "Even the gladioli waited to bloom!"

Chapter Nineteen

Times square? Don't you girls even *think* about going there," Mr. T.C. said with alarm. "If the surrender is announced today—it'll be *pandemonium*."

"Don't worry about us," I said, surprised by his concern. "Remember the millions who turned up for the Eisenhower parade? Wouldn't have missed that for the world."

It was Tuesday, August 14. All anyone could talk about was when Japan would surrender . . . and now it seemed that time was very near.

"I don't want to miss a thing," Marty said, "but no one knows when Truman will be announcing it and I don't want to stand around Times Square for nothing!"

But Carolyn and I had already agreed that we didn't want to risk the chance of missing this historic moment, so we made a plan, promising to call Marty if there was news.

Carolyn said she'd be waiting outside Saks Fifth Avenue at four o'clock, and I knew I'd have no trouble spotting her. Carolyn was a head-turner. Once, when we were walking past Rockefeller Center, an admiring crowd of sailors had wolf-whistled, following up with a hearty "hubba-hubba," as she sidled past. Today, from almost a block away, I spotted a smart black-and-white-striped dress with a black patent-leather belt and black ankle-strap heels, and knew immediately that that was Carolyn.

When we reached the subway platform, two nuns in their fastidious habits were sitting on a bench waiting for a train. Carolyn curtsied in front of them and asked if she could help. They smiled, murmuring *Merci, Merci,* but did not need assistance. And I admired her thoughtfulness for the sudden throng of people trying to board the train for Times Square might have crushed them.

We could scarcely breathe—or didn't want to—as we were pushed inside the next train without an over-head strap to hang on to. When we emerged from the

station, the streets were bursting with people, and traffic was at a standstill.

Carolyn and I decided to head for one of our favorite restaurants, Toffenetti's. Carolyn forged ahead and I kept my eyes tethered to her black-and-white dress as we dodged past barelegged girls with flowers in their hair, kids with flags and balloons, men and women in military uniforms, and mothers wheeling baby buggies.

When I stepped on freshly discarded bubble gum, my shoe pulled right off my foot, but Carolyn wasn't stopping for anything. Carrying one shoe and stepping more carefully, I finally saw the Toffenetti sign with the tantalizing billboard promoting cantaloupe and ice cream. When Carolyn finally stopped to wait for me, she pointed to the line for the restaurant that ran down the block.

I would have waited forever for a booth at Toffenetti's, but Carolyn would have none of that. We would go straight to the Hotel Astor, on Broadway between Forty-fourth and Forty-fifth Streets, and claim our spot for the perfect view of all of Times Square.

"Elbows out," she yelled as we pushed on, but only after I stopped long enough to scrape the bubble gum onto the curb. A group of sailors was marching arm-in-arm singing "Anchors Aweigh," boys were

climbing a light pole, and servicemen were pouring out of the Astor Bar, around the corner from the main hotel entrance. As we reached our destination, two navy commanders were giving us the eye. The taller, dark-haired officer strolled over to Carolyn, and offered her a Lucky.

"Hey—what're you girls doing in this mob?" he asked as he pulled out his Zippo lighter and lit her cigarette. "How about joining a party—our squadron has a suite here at the Astor."

We exchanged hesitant glances. That would be one way to escape this crowd, I thought. And Carolyn was thinking the same thing.

"Come on," she said when the other commander joined us.

The four of us headed for the lobby. We were silent in the elevator, a welcome relief from the hubbub on the street, but awkward. I didn't know what to say to the sandy-haired commander who seemed to be—my date? He said his name was Brian, from Philadelphia. Carolyn chatted away, lighthearted and laughing.

I tried to join in, wishing I had her gift for small talk. Finally I gave up and stared at my shoes. My right one was still sticky. I had the distinct feeling that this older guy with the solemn face was a married man.

When we entered an upper-floor suite, we collided

with an officer who had a girl on each arm singing "*Chattanooga choo-choo—choo-choo . . .* " as they staggered past. A blue haze of smoke enveloped the room; chairs and sofas had been pushed to the wall to make room to dance. Peanut shells, popcorn, and cigarette butts crunched under my feet. Only one couple was dancing, to "Stardust," which was playing on a Philco phonograph, the volume turned up, while other couples were drinking or necking on every available sofa or chair. Bright posters on the wall spoke of the last four years: *Loose Lips Sink Ships* and *Sock Your Money in War Bonds.* The room reeked of smoke, whiskey, and stale beer.

"How do you like your Scotch—water or on the rocks?" I was asked.

The *rocks*? What was that?

"Water, please," I said, grateful for anything wet and cold. A bellboy was supplying ice, cigarettes, and bottles of rum to a makeshift bar that had been set up in the middle of the room. Though it was a bright, sunny day, the suite was gloomy and dark, except for flashes of neon lights from the street below.

I nudged Carolyn. "Let's leave."

She gave me an eye-roll as her commander lit another Lucky for her. She was in no rush.

The Scotch quickly numbed my lips, though I was

trying to sip it slowly. What an awful drink! Brian—
or whatever his name was—rescued pillows from a
couch so we could sit on the windowsill. He took out
his pipe, filled it, and reached for my knee. I reached,
too, to keep control of my accordion-pleated skirt. I
was desperately trying to think of something—any-
thing—to say. What about: *Do you have a picture of
your wife—or kids?* Instead, I stared into my glass of
Scotch as though I were fascinated by the melting ice.

"We need another round," he said. No, that was
definitely not what I needed.

A burly officer was leaning against the bar crooning
"Rum and Coca-Cola." He stopped singing when he
saw us. "Whoa-whoa-whoaaa," he said in a suggestive
voice as his date, a woman in a satin fuchsia dress, sent
him a cross look.

Whoa is right! I looked for Carolyn, and couldn't
see her.

As I scanned the room more anxiously, the com-
mander handed me another Scotch. He pointed with
his pipe to an open door leading to other rooms. I
shook my head "no."

"I have to find my friend," I said firmly, trying
to hide any desperation. "We're supposed to meet
someone. . . ."

Crash!

"Judas Priest!" wailed the woman in the fuchsia dress.

Now what! This place was out of control.

The bar had collapsed and the lieutenant went with it. On the floor, he was surrounded by broken glasses, gushing bottles, and spilled ashtrays, with most of the ash in his hair. He looked up through bleary eyes to see his date, whose fuchsia dress was now drenched in spirits. She let out a louder "*Judas Priest!*"

I hurried through the melee, the smoke so thick I could barely find Carolyn. "So much for this *bash!*" she said, grabbing for my hand.

"We'll just slip right through the door," I said as we linked arms.

She laughed. "How about singing 'Chattanooga Choo-Choo'?" as we charged past the doorway for the elevator.

"I prayed," she said breathlessly. "I vowed if I could make it out of there, I'd crawl on my knees to the closest church!"

"Me, too!" What were we thinking? How naive could two girls be!

The lobby of the Astor was reeking with perspiration and smoke. I could hear Nat King Cole playing

his popular version of "Sweet Georgia Brown" and servicemen, three deep, were trying to crash the famous circular bar.

"I've got to call Marty," I told Carolyn once we had regained our equilibrium. "She can't miss this." Everyone seemed to know that the announcement of the end of the war would happen sometime that night. Marty picked up the phone immediately, and agreed to meet us in front of the Astor at 6:30. Surely she could make the trip in an hour.

By the time we reached the street, people were leaning out of windows, perched on overhead ledges and fire escapes, clinging to light poles, or sitting on someone's shoulders. Everyone was jockeying for the best view of Times Square. Broadway was packed tighter than tobacco in a smoker's pipe, and I began to panic. How would Marty ever find us in this mob?

As we waited, eyes glued to the Motogram Zipper on Times Tower for a change in message, I saw an army sergeant who looked miserable and lost.

"Hey, gal," he said, questioning the concern in my face that was simply mirroring what I saw in his. "Why aren't you smiling and laughing? My buddy's never going to laugh again."

His words stopped me cold. Seeing his eyes fill with

tears, I groped for a comforting response. "I'm so sorry," I said at last. "I know how you feel—my cousin died, also." We stood there speechless, until someone yelled, "Hey, Sarge. Over here!" and he was gone.

"It's six-thirty," Carolyn broke in. "Where's Marty?"

A sea of people were in the street, pressing and shoving to reach the corner of Forty-fourth Street. It was no place to be; we should have heeded the warnings. I shuddered to think of Marty by herself.

"We have to wait—she'll be here," I assured Carolyn, as if Marty would magically land in front of us. We stayed rooted to our spot with one eye on the Times Tower and the other on the street. Suddenly, at three minutes after seven, the big screen went dark. The crowd seemed to pause momentarily in anticipation. When the lights came on the screen read:

OFFICIAL TRUMAN ANNOUNCES JAPANESE SURRENDER

A thunderous roar rose from the crowd. Church bells pealed, air-raid sirens wailed, cars honked, tugboats tooted, firecrackers exploded, and people cheered as

confetti and paper fell from the windows. Near me, an old man threw his cane in the air.

An army private kissed every girl he could find. Including me. Streams of tears ran down the cheeks of an elderly woman as she watched the words circling the tower.

No one was a stranger in that crowd. We had all heard FDR's "Fireside Chats" and Edward R. Murrow's "This is London," listened to H. V. Kaltenborn for the evening news, and watched the newsreels before the movies. We'd read Ernie Pyle's columns, planted victory gardens, written V mails, sent care packages, gathered phonograph records for the USO, given up nylons for parachutes, saved bacon grease for explosives, and turned in tinfoil, saved from gum wrappers, for ammunition. Most of all, we'd prayed that our loved ones would be safe.

But still no sign of Marty.

Carolyn and I had managed to keep our spot in front of the Astor, and we both resumed our crowd-watching, looking for any sign of her and growing more nervous as the throngs became more aggressive, pushing and shoving. It was so loud, it was difficult to even talk to the person standing next to you. Was that flash of blue Marty? No. I would jump up to get

a better view over the crowd. That familiar head of hair? Marty? Yes, it was! We waved and shouted her name though we quickly realized she couldn't hear us. If I could only whistle! Finally, we did catch her eye and she struggled toward us.

"It took an hour and a half to cross the *street!*" Marty gasped, her face damp with sweat. "I can't believe I found you!"

We hugged each other. We were together. Reunited.

Caught in a chaotic stream of people, Marty, Carolyn, and I were driven up one block and down another. Where were we? We didn't know, we didn't care. Flowerpots were smashing. Firecrackers were tossed from fire escapes. Feathers from pillowcases floated through the air. Sidewalks were buried in confetti, shredded telephone books, and ticker tape. People were dancing on top of cars and every bar and nightclub overflowed in the streets, with celebrants shouting, kissing, and singing. Filled with that wild sense of exhilaration, we could have walked forever. Later, the three of us never recalled what streets we'd taken until we found our way home. When we finally reached our apartment at 3 o'clock in the morning, not even the desk clerk was surprised. The papers later reported two million celebrants were in Times Square that night!

And the celebration did not end there. Harlem celebrated for days, firecrackers exploded for weeks, and in Little Italy the wine flowed for a month. After three years, eight months, and seven days of war, it was VJ Day. A day that would never be forgotten.

106 Morningside Dr.

Dear Family,

Just a quick note to let you know—we did go to Times Square. When we saw the news of the surrender everyone went wild! There were over two million people there—can you imagine that? You asked about the lights on Times Square. On the building there are fifteen thousand lightbulbs. They move in a panel five feet high around the building—two men operate it! Yesterday it read: OFFICIAL—TRUMAN ANNOUNCES JAPANESE SURRENDER. I'll be curious to hear about your VJ Day.

I can't help but wonder what life will be like now that this war is finally over.

Please give my love to Aunt Olive and Uncle Peter.

Love, Marjorie

The carillons were playing "America the Beautiful" as Marty and I hurried across the Columbia campus to the Riverside Church. I could feel the vibrations under my feet from the seventy-four bronze bells—the largest carillon in the world. The church towers loomed over Morningside Heights like a beacon that morning, and crowds poured in from every direction. We found a seat in the nave, and I held my breath as sunlight streamed in through the sixteenth-century Flemish stained-glass windows and the organist played a Bach prelude. We had come to celebrate the day with Reverend Harry Emerson Fosdick—better known to New Yorkers as "Fearless Fosdick" due to his outspoken views on social injustice. Never had his famous words "Liberty is always dangerous, but it is the safest thing we have," sounded as true as they did that day. And I never heard a congregation sing hymns so urgently and vigorously. It was an unforgettable experience to be present at the Riverside Church that day, August 16, 1945—the day after the war's end—and to express how we felt with tears, joy, and thanksgiving. I was surrounded on all sides by New Yorkers, but had never felt closer to home.

Chapter Twenty

How about a quiet place—a place we can talk?" Jim asked, on our way to Riverside Drive.

"I'd love it," I said, trying to keep up with his long stride.

"A guy told me about a pub—though it's way out in Greenwich Village. But we have plenty of time tonight," he said as we boarded the Riverside bus.

Greenwich Village, so different from the rest of the city. A place to breathe with park benches, trees, and narrow, winding streets. We strolled hand in hand past Washington Square, admiring a secondhand bookstore with a red doorway, a sidewalk café in a narrow street, and abstract paintings propped up against a building.

"Here we are," Jim said, pointing to the Van Rens-

selaer Hotel. Through the lobby, we entered a small room with comfortable out-of-date chairs, low tables, and a bar. Dim lights cast shadows on the faded wallpaper. There was a murmur of voices, as if we were in a library, and a few marines were playing a game of darts in the corner.

Jim found a table in the back of the room to stretch his legs.

"Hey, hope you like this place—I heard about it from a guy."

"I'm no expert—but this doesn't look like a bar. I feel like I'm in someone's living room."

"Maybe it's New York's version of an Irish pub with great ten-cent beer." He raised his eyebrows and set a daiquiri, a beer, and peanuts on the table. "On VJ Day we toasted at the base with New York City water. How about you?"

"What I had was not worth mentioning." *In fact I'm not mentioning a word.* "Can you leave the navy now that the war is over?" I asked.

"No way. It looks like we'll be sent to Newport and maybe overseas—that's the scuttlebutt."

"Overseas!"

"Yup—could be the Pacific," he said, lighting a cigarette. "Nobody's saying much right now." I had been

thinking ahead, and I had been thinking about Jim. I hadn't realized his commitment remained, war or no war. This war wasn't really over after all—at least not for us . . . if there was an "us."

"Post time!" the bartender called out. The marines left their dart game, a couple in front of us let out a whoop, and the room became quiet. "What's going on?" I whispered to Jim. He shrugged and smiled. The dapper bartender, a small man with his dark hair slicked back, reached for his guitar and pulled up a stool from behind the bar, strumming a few chords. In a mellow tenor voice, he began singing,

My pretty Colleen—in a gown of blue-green—

Jim whispered, "I knew you'd like this place" and reached for my hand.

Up and down the bar customers paid rapt attention as the bartender sang several nostalgic Irish tunes—and when he repeated "My Pretty Colleen," everyone joined in, clapping as he did a shuffle dance at the end of his little act. The melancholy tone of his voice had made me wonder if he was homesick for Ireland and if he'd learned these songs from his mother or father as a boy.

When he finished there was exuberant applause.

"He has a wonderful voice," I said, glancing around

the room, suddenly realizing every table was now taken. "Look at his following—I'm glad he's appreciated."

"And do people appreciate the instrument you play?"

"You've forgotten what it is—"

"Just teasing," he said with a grin. "If I'd known a cello could get you into Yale—I'd have taken it up myself."

I shook my head, still in disbelief myself about that turn of events. "I've got to figure out how I can ship my cello," I said. "That, and a million other things. . . ." My conversation with Mr. Koelbel was at the top of the list.

"Did you ever have a prof who went out of his way for you, offering opportunities and determined to see you succeed?" It was as if the question popped out of my mouth before I even knew I was going to ask it.

"You bet—that's how I got into chemistry. I would never have known about so many great new fields if he hadn't taken the time to be a mentor," Jim said.

"Speaking of chemistry—I just heard from home that Iowa State, where I transferred from, was working on part of the atom bomb in our chemistry building! Remember when I told you about the fire, and how we couldn't leave the lab? Guess what—they were *purifying uranium*—right there on the floor above us!"

"Are you serious?" Jim's eyes widened. "Uranium? It's a wonder you didn't light up and glow like a light-bulb," he teased.

I laughed as if I knew what he was saying, but couldn't remember one thing about uranium.

"Hey, that reminds me—I have something for you." I pulled out the two packs of cigarettes I'd bought back in Iowa, when I was determined to learn how to smoke. "You can light up with these."

Jim was baffled until I explained, then he was relieved.

"Now tell me about that ship you were on—the one in the Hudson River?" I asked, desperate to change the subject.

"You'll think I'm exaggerating," he said. "It was an old Spanish-American war–era battleship—with the superstructure removed. They replaced it with a wooden structure. It was called The Prairie State." He took a cocktail napkin, and doodled a version of it. "Looked to us like Noah's ark."

"No wonder you didn't have telephones near you," I said, feeling guilty. "Bet you never knew the navy would be like that." I looked down at the napkin. "So . . . have you ever thought about what you might want to do when you get out?"

"You bet. Probably go on to grad school—chemical engineering's opening up fantastic opportunities, particularly in plastics. You won't believe what things will be like ten years from now."

Then he asked me, "So what do your parents say about your big deal at Yale?"

"Well," I said, "you'll think this is weird . . . but they don't know yet."

"For cripessake! Why not?" Jim almost spilled his beer, and his face had the first hint of disappointment I had seen.

My eyes were stinging as I tried to force back tears. "Every time—it's like—" I tried again. "Every time I write home I don't know how to tell them . . . yet I know they'd be so proud. So I'm going to call long-distance instead."

"Why don't you just take the train home—you'll have a chance to see them—and then come back?"

Easy for him to say. There were things he didn't understand, including the simple fact I could barely afford a ticket to New Haven, much less a new round-trip ticket from Iowa to Connecticut. The silence was awkward—and I was surprised Jim actually cared about where I finished college . . . *What did that mean?*

"Hey—don't worry." I forced a smile. "I'll work it out—I know I can."

He shook his head, and laughed lightly. "Sometimes I just don't understand women."

Just then a group of midshipmen and their dates entered the bar and were chatting with the bartender. The place was so packed that customers were now lined against the wall.

"Post time!" the bartender broke in again as he wiped down the bar.

"Why does he say that?" I whispered.

"At horse races, they call 'post time' when the horses are at the gate and the betting windows close—they love their races here."

I leaned closer to him. I never wanted the evening to end. As the genial bartender warmed up with a funny ditty someone from Boston had requested, Jim had his arm around me—my cheek in the hollow of his shoulder. We hung on to every note, listening, not talking.

After one of the songs, he said, "There's something I want to ask you. Don't you think that my Phi Delt pin would look nice next to your Kappa key?"

I caught my breath. All I could do was smile and nod my head.

A lock of his hair fell forward when he smiled, and the bartender was singing:

"'*She came runnin' down the mountain—runnin' down the mountain—runnin' down the mountain to the lad that she loved.*'" Jim kissed me. And once again.

106 Morningside Dr.

Dear Family,

How shocking to hear about the Iowa State connection to the atom bomb! Who would have thought Iowa State would be involved with *that*—and Ames is practically next door! I guess we at least found out! No wonder they had all of those guards.

So much has happened—you'll never guess! Jim's asked me if I'd like his Phi Delt pin! No, it doesn't mean we're engaged—but we have an understanding! He's planning on grad school after the navy. I really want you to meet him! You'll like him a lot!!

Jim took me to a fascinating place in Greenwich Village, where we heard a real Irish tenor. Don't worry about our being out at night—we know our way around!

Much love, Marjorie

Like heck! When Jim looked at his watch, I'd never heard him swear like *that*! His curfew was twelve! We made a beeline for the subway—ran eight *blocks*. The wrong direction! Where were the buses? A taxi? None in sight! Climbed the steps to the elevated train—wrong way, *again*! Got off, and sprinted down the steps. Flew along streets for blocks looking for the next subway till my side ached. Thank heavens I was wearing my sandals, not my high heels.

We finally found the subway entrance and jumped on the train. We dashed to my apartment, there was a very quick goodnight kiss, then Jim tore off for the base. Would he get any demerits or be placed on restriction?

How could a perfect night end like that?

Chapter Twenty-one

I was awake. The bedside clock read 4:00 A.M. as I faced the still-dark morning, lost in memories of the Van Rensselaer with Jim. But as I drifted into consciousness I recalled Jim's look of dismay that I hadn't notified my parents about Yale. I dozed off again until Marty's Tweed perfume woke me with a start. She was already dressed, combing her hair in front of the mirror, "Hey—do you know what *time* it is?"

I wanted to pull the covers over my head. "I know . . . I *know*," I said, touching the bare floor with one foot so I wouldn't fall back to sleep.

I was half awake when we boarded the subway. Careering around a corner, hanging on to the over-

head straps, Marty and I laughed, remembering our first ride. Before crossing Fifty-seventh Street, Marty turned.

"How about Schrafft's for lunch—like we promised."

"Fantastic—meet you at twelve sharp!"

It was an uneventful morning on the third floor, with mothers and daughters choosing their china and crystal patterns, and signing up at the Bride's Registry. *Maybe I'd be next to sign up.* There were lovely affordable items: crystal nut cups, Tiffany demitasse spoons, Spode teacups—or the teapot in the English Hunt pattern.

Between orders to the shipping room, I began paying more attention. Because Tiffany didn't have price tags, I'd have to ask. A dozen Crown Derby dinner plates were $62, an elegant oval vase $12, and a dozen etched cocktail glasses were also $12. There was a bargain! Though anything from Tiffany would be a treasure to me.

On an errand to the cashier on the main floor, I caught sight of Marty, talking to Mr. Scott. She tilted her head to the clock—ten minutes before twelve.

Filled with anticipation, Marty and I walked into Schrafft's. Marty fit right in with the lunch crowd wearing her elegant navy blue shantung dress. She may

have used a Simplicity pattern but it didn't look simple on Marty. The room was filled with flowers, white damask tablecloths, and the aroma of cinnamon rolls just out of the oven. Elegant decorated tins of chocolates were displayed on a counter.

"Ooh," squealed Marty, "that's what I want to take home. Look at this gold tin!"

The gold tin had a lovely etching of an oriental lady in a sedan chair; it was one you'd want to keep, maybe as a sewing basket. I looked at it, too, suddenly feeling stricken. I wouldn't be going home, let alone bringing a gift.

We were led to a table and given a long impressive menu. My finger slid down the list of desserts. How could one decide? But the waitress was standing at attention, her pencil poised. At the bottom of the menu I read: *Due to rationing only some of these meat items are available. Ask your waitress.* No problem—we were there for the sinful desserts.

"The fresh peach sundae for me, please," Marty requested.

"I'd like the hot-fudge pecan sundae, please," I said, as if it were a dietary staple.

The waitress waited and then said, "Your lunch entrée?"

"We've had lunch, thank you," Marty said. "We're only stopping for a little ice cream—it is your specialty isn't it?"

The waitress agreed and left.

"Thanks, Marty, you saved me!"

"If they only knew what we carry in our coin purses!"

The sundaes arrived in tall translucent glasses on a lacy doily. My hot fudge puddled around a large scoop of ice cream, coated with pecans topped with a maraschino cherry. I had never tasted anything so delicious. Ever.

But then my eyes filled with tears. The one secret I had kept all summer was my Yale plan. . . . I hadn't let anyone know except the Shuttleworths and Jim, because I didn't want to take the chance that my parents might learn about it before I had had a chance to tell them. I felt terrible, because Marty was my best friend, and she could keep a secret, if asked to. Now I told her the whole story.

"Ohmygosh." She was stunned. "You might not be going back? Are you serious?"

I shook my head. "I thought I was. But I still haven't told my folks and I'm not sure I can make this decision. . . . I . . . I just wanted you to know what's going on. I can't decide, but I know I have to very soon."

She could still see the pain in my eyes, that there was nothing more to say now, so she changed the subject.

"Do you want to know what I found out about the Windsors?"

You bet I did.

"Our Fifty-seventh Street guy knows everything. He has inside tips from the Waldorf—that's where they stay, you know."

"*And?*"

When Marty had hot gossip, she could tease.

"Well—" she said, and began looking for her cigarette lighter.

"We're going to see them?" I asked impatiently. I knew the Windsors had worn the seats thin in the Tiffany VIP room.

"'Fraid not. But I know who is seeing them in Palm Beach," she said with a gleam in her eye. "Happens to be a friend of yours—that playboy, Jimmy Donahue! Wouldn't it be a *riot* if those earrings were for the duchess?"

"Ohmygosh!" I shrieked, startling the ladies at the next table, their eyes as wide as owls'.

When we finished, I stopped at the display counter to look once more at the chocolate tins. Marty joined me. "Forget something?" she asked, holding up my purse.

"Good night! What's the matter with me?

She shook her head. "Remember the time you left your coat?"

"At the football game—and you brought it back? Oh Marty," I said, suddenly somber, "what will I do without you?"

That afternoon, Mr. T.C. was showing me a Wedgwood tea set when he looked up. A plump lady was standing near the elevator with a bewildered look. I tried not to stare as Mr. T.C. swooped to rescue her and escorted her to a chair as if she were Queen Elizabeth.

Except for the lustrous string of pearls dangling to her waist, this lady would never be mistaken for royalty. She looked as if she'd been rummaging through my mother's cedar chest, wearing a too-short yellow chiffon dress with wide ruffles, black-and-white pumps, and a cloche hat that didn't disguise her thinning red hair.

"Oh, my." She fluttered, holding out her gloved hand. "How lovely and cool it is here. I told my driver—'only Tiffany's today in this horrid heat.' I wouldn't be out at all except to buy a wedding gift." She sighed. "Young people don't know the proper time to get mar-

ried anymore. But now that the war is over . . ." Her voice trailed off.

"Does the bride-to-be have a pattern?" asked Mr. T.C. with a take-charge voice.

"Oh, indeed she does—she's my goddaughter. It's the gold-rimmed Minton. Is it very dear?"

"It's one hundred dollars a plate—but of course the very best," he assured her.

"Oh, my gracious, I had no idea!" She reached for her handkerchief. "What if one should break?"

"Minton is very strong, Madam—made from real bone, you know." He brought a plate to show her, snapping it with his finger to make it ring.

She shook her head. She wasn't convinced.

"They're a treasure, Madam," he persisted. "If you examine this engraved design on the gold rim, you'll notice the exquisite craftsmanship. There are four layers of gold, fired separately and then polished until they gleam. The women who polish the gold use special stones from the Rhine."

"The Rhine *River*?" she asked, leaning closer to examine the plate.

He nodded. "Yes, Madam, it's the stones from the Rhine that give it that brilliant shimmer of gold—and these women are experts."

"Oh, yes—I've heard of them. There's a Miss Rheingold Contest every year!"

I bit the inside of my cheeks to keep from laughing. Mr. T.C. was having trouble keeping a straight face. His precious Minton in the same breath as Rheingold beer!

With a sly smile, he stepped back in his British wing-tip shoes, took the plate in his hand. He put his thumb on top and flipped his wrist—making the plate spin in the air.

Holy moly! *Had he gone berserk?*

My stomach lurched as the plate seemed poised forever in space before it sailed to the floor—*unbroken.*

While Mr. T.C. smiled with the aplomb of a master showman, I heaved a sigh of relief. From his smile, I knew. *That rascal!* He'd never take the slightest chance of causing the tiniest chip—he'd probably practiced this spectacle hundreds of times. However, if I so much as brushed up against one, I'd be the new indentured servant. Was there anyone comparable to Mr. T.C.? Perhaps P. T. Barnum.

"Very strong china." He grinned.

"What a fright!" our customer said, patting her ample bosom. "I would never have believed it! Dear, oh dear," she said, after putting her lacy handkerchief

into her beaded bag, "I guess my goddaughter does have good taste. She's too busy to come along with me, but she knows what she wants. I'll take a dozen."

A dozen? *Over a thousand dollars for dinner plates?*

"A perfect choice," Mr. T.C. agreed, not a bit fazed. "Your goddaughter is most fortunate."

"Well, she is a darling—finishing Smith, you know," she said, and lowered her voice, "but quite caught up with herself, I'm afraid."

"So kind of you to choose this wedding gift," Mr. T.C. reassured her.

"It's what my dear husband would have said—always be kind. You don't have to go to a fancy school like Smith to learn that."

She smoothed a ruffle on her dress, placed her handbag on her lap, and opened it to show him a snapshot of the girl.

"Pretty thing, isn't she?" she asked. "President of her rowing club, one of the school's yearbook editors, and has prizes for high marks. Now she's getting married." She sighed. "All that money wasted on a college education."

"But think how proud you must be of a girl who's so successful," he said, looking at the photo.

"I'm of the opinion there are more important things

for a girl to learn," the woman said emphatically as she wrote out a check. "I always say—*the true measure of a person's success is to be a person of value.*"

I wanted to tell her—in this day and age, life is different. Accomplishments are everything. How else can you be successful, I muttered to myself as I carried her generous check to the cashier. At one glance, the cashier nodded and smiled. He didn't need to lift the phone for her check. She was one of their Social Register customers. I should have known. And with all that money—to hear this woman imply that college was a waste!

My parents would have set her straight. Going to college was an insurance policy, my father said. Besides that, what could be more fun? To hear mother's St. Olaf College stories: the parties in her room after "lights out," the pranks on Miss Hilliboe, the funny messages sent to the boys at Ytterboe Hall. Later, when our cousins came home during college vacation, I made every excuse to be near the "big" table at Aunt Olive's to hear their stories and peek at the new girlfriend or boyfriend. Like Betty Ann's handsome football captain. *Ohmygosh.* College was not a waste!

When I reached the third floor, Mr. T.C. was still charming the old-fashioned lady. "Oh, my dear," she

said to me, "you've been so helpful—you'll find that working here is better than running off to college."

Mr. T.C. winked as she left. And he didn't know the half of it.

106 Morningside Dr.

Dear Family,

Excuse the pencil—can't find my pen. At the Shuttleworths', Mickey showed us her latest find—a beautiful Italian majolica platter from the "Going, Going, Gone" shop at Lord & Taylor. Abby, who works at Lord & Taylor, has been watching it for her as it went down in price— each week Mickey held her breath. Her anxiety was so overwhelming till she bought it! And it resembles her great-grandmother's lovely teapot. Imagine that luck!

Yes, we've been to the museums. The Metropolitan Museum of Art is our favorite. On the first landing, there's a vivid painting of Levine's String Quartet—very striking—I do want to get a poster of it. Also, the Museum of Modern Art—the Salvador Dalí is fascinating. Next week—a ride on the Robert Fulton steamer to Bear Mt. on the Hudson River! Finally saw a

Yankee game! Sorry to say, we left early, Phil—it wasn't a fast game like the ones Dutch Reagan announces. I told Jim that you play football and started a laundry business for the team with Bruce! He was impressed! Can't wait till you meet him!

Do you remember when I wrote about meeting a Yale faculty member and playing the Brahms sonata? I hear they have a *wonderful* music program there. Ask Aunt Cosette about it when she comes; she'd be impressed.

Love, Marjorie

I am dancing! Jim called to say that he made curfew—our Saturday date is ON! *Then* Marty pulled out tickets for Broadway's biggest hit—*The Glass Menagerie* with Eddie Dowling and Laurette Taylor—Mr. Scott gave them to her! "Better than clams." She laughed.

I'll never forget Laurette Taylor's telephone scene trying to sell magazine subscriptions. It was sad and funny at the same time. During intermission Marty heard that Eddie Dowling might be at Sardi's, so we joined the after-theater crowd. Dowling didn't show, but the crowds poured in with standing room only. It

was the liveliest spot in town—open all night waiting for the early-morning reviews. The gorgeous dresses, the high-style hair-dos, the gossip—the hugging, the kissing, and everyone yelling "dahling." New Yorkers, so uninhibited. We were bug-eyed. All for the price of a ginger ale!

Chapter Twenty-two

Our last day at Tiffany! Searching through the upper drawer of the dresser for my best stockings, I heard Marty shout, "We're going to be late!"

"I'm ready!" I yelled, dashing for the door. "Just a second." I ran back for Mother's letter, thanked the elevator operator for waiting, and raced to the subway with Marty.

That morning, Mr. T.C. sent me on several errands. I was grateful, for it gave me the opportunity to say good-bye to everyone, particularly the shipping clerk.

"Ye leavin' already?" Jack asked, leaning on the counter, his eyes as blue as the boxes behind him.

I hoped he'd tell me another Tiffany story or tease me about Jim so we could share a final laugh. Instead,

he shook his head, staring at a faraway corner. "So, lass . . . it's good-bye, is it?"

I nodded. I stood there as if glued to the floor, not wishing to leave, for I knew I'd probably never see this sweet man again.

At noon, I went to the locker room to reread my mother's latest letter. She began with the usual news:

"Katherine is looking well. . . . Phil is already practicing for football. . . . Could you play at church before going back to school? Cosette will be here next week. . . ."

I tucked the letter back in my purse. I'd be sorry to miss seeing Aunt Cosette; she'd be amazed by the news: "Yale! Hindemith!" she'd exclaim. I had waited too long to write; I had to call my parents this weekend to discuss my change in plans.

By the end of the afternoon, the third floor was quiet, empty of customers.

"Miss Marjorie," Mr. T.C. called, "please come to the front of the floor." The other salesmen were waiting for me. I had a knot in my stomach, knowing it was time to say good-bye.

"So," he said, "we're going to miss you around here."

I swallowed hard.

"Just so you won't forget us, we'd like you to have this." He handed me an elegant brochure, creamy white and deckle-edged with a drawing of the Tiffany building on the cover.

"We thought you'd like to remember the store—there are drawings of all three floors," he said, turning the pages for me to see.

"And there's a drawing of the Sheraton table," William added, and we laughed.

"How could I forget *that*? This brochure is lovely—and now I can remember every detail. You've been so *wonderful* to me."

"And we also have a gift for you," Mr. T.C. said, walking to the counter.

"For me?" I echoed.

He nodded and reached for a tall blue Tiffany box.

For a moment I couldn't even speak. "This is for *me*?" I said at last.

They watched as I untied the satin ribbon. With trembling hands I lifted the cover. It was a Spode teapot in the Hunt pattern. The moment took my breath away. My teapot! Did they know how often I had admired it?

"We wanted you to have something you could always use," Mr. T.C. explained. "But—this is important," he said, tapping on the blue box, "never reuse this box. It's our trademark."

I tried to remember the farewell speech I had gone over in my head, but it flew from my mind. Although I'd known this moment would come, it was overwhelming.

I finally stammered, "I can't thank you enough . . . I'll treasure these gifts. I'll keep them *forever*."

"Don't forget to come back to see us," Mr. T.C. said with his droll smile.

"You know I will," I promised.

"One last thing," he added. "Don't forget the proper way to sniff brandy."

Everyone laughed. How I needed that comic relief.

Still, as I waved good-bye from the elevator, I was unable to see them clearly through my tears. I hugged the box on the way to our locker room, overwhelmed by such kindness.

In the locker room, I held the Bonwit's dress, the silky fabric warm on my fingertips. I felt a lump in my throat as I remembered all the times I had worn it. The way my uniform gave me the courage to enter the main floor that first day, feeling like a model. The time the skirt had saved the pearls in the elevator so they wouldn't escape. The time the silky feel of the sleeves made me think I was a debutante, swirling brandy. I remembered again the surprise that first day when the secretary lifted the dresses from the tissue paper,

taking our breath away. How proud we'd been wearing our dresses, preening in front of the mirror, knowing we were members of the Tiffany family. All summer long my dress had been there for me, sharing the moments. It was *so* much more than a dress. But now it was time to put it back on the hanger for the next girl. I stroked the fabric, straightened the collar and the perfect pleats, then hung it up for the very last time.

As I sat down on the green bench, I reached for Mother's letter to read one more time, feeling only guilt about my procrastination. I visualized Mother at the walnut desk in the corner of the dining room writing the letter, sifting through the day's events to write me only the good news. When you're a thousand miles away, why worry anyone? Keep your feelings to yourself, we always said.

I read the first page and my eyes circled back, reading it once more. The blue ink began to blur; my hands were sweaty. . . . "Lots of nice apples," Mother had written in her even backhand. I'd heard that before. A windfall of apples was a godsend before company arrived. Festive dinners with apple rings, apple butter, and apple crisp for dessert. How lucky. How fortunate to stretch the meals and stretch the dollar. *How far would the dollar need to stretch for me now?*

I heard the familiar hum of voices in the hall. The elevator door had opened and closed as I listened for Marty's footsteps. I looked at the dress hanging in the locker once more, knowing the best summer of my life was almost over.

The moment I saw Marty's face when she entered the locker room, I knew it hadn't been easy for her to say goodbye, either; and in Marty's eyes, I found an inexpressible comfort.

When we left Tiffany's for the final time, we smiled bravely at the man who had clocked us in each day, and who had shown us the way to the Automat and the subway. It was our last good-bye. He wished us good luck, and waved.

Standing outside on the corner of Fifty-seventh Street and Fifth Avenue, we turned to look at the familiar building once more: the sturdy, gray limestone, the towering stonework that had first intimidated me. Perhaps it was the glow of the late sun or the blur in my eyes, but that afternoon the limestone had a luster and sheen that gave hint of a magical sparkle. The very same sparkle that had transformed two Iowa girls that unforgettable summer.

Linking arms, we vowed that we'd be back as soon as possible.

My last Saturday morning in New York and I'd overslept!

What was the time? Eleven?

Eleven!

I rushed to the shower, combed my hair, and used up the last drops of my Evening in Paris. Jim would be arriving any minute.

On the desk was a note from Marty. "Carolyn and I are going to Rockefeller Center—still celebrating! See you tonight."

So many places on our list to see before we had to leave. Today, Jim and I were going to Central Park. I felt light-headed.

Wearing my sundress, I ran down the stairs without waiting for the elevator.

On the last flight, I caught sight of Jim coming through the door. *Jim.* If only I could keep running down the stairs and through the lobby and throw my arms around his neck. But my proper upbringing wouldn't allow such a display. Not in broad daylight!

Jim was smiling.

I smiled back.

The desk clerk grinned. Even our Russian neighbor looked cheery as she came in from her walk. What an amazing, extraordinary day.

"Ready, kiddo?" Jim asked, grabbing my hand.

As we climbed the steps to the top deck of the Riverside bus, we found seats in the front row.

"Just like our first date," Jim said.

"I'll never forget—"

"How you pretended to be a good sport—going to the Jack Dempsey Bar?"

"Were we surprised!" I laughed.

"Are you always that good at covering up your feelings?"

"It's important not to disappoint anyone, or make them worry."

"It's just that sometimes you're hard to read, when you don't express yourself," Jim said, putting his arm around me. "So—did you make that phone call to Iowa?"

Oh boy. My smile froze, then disappeared.

"Too bad," he said.

His tone was noncommittal, but I saw his disappointed look. He didn't understand. It was my own fault. No excuse for putting it off so long. My high

spirits vanished. Trying to think of something else to say, I looked across the street at the Riverside apartments.

"Look!" I pointed, to distract him, "on the next block—that's where my aunt Cosette lived." *Well, twenty-some years ago.*

"I like to imagine which grand apartment was hers. I can just see her there when she went to Juilliard, studying with Lhevinne," I babbled on. "She lives in California now—she moved there after studying in London."

"I'd think your mother would be envious—New York, London, California—"

"No, I'm sure she isn't. Besides, my great-aunt Margretha warned us not to show our feelings—it's a sign of weakness. We should not fall apart, complain, or envy others." I recited her words like a child.

Jim nodded. "So—are you too Norwegian to ever cry?"

"Of course not—everybody cries sometime. Maybe I cry too easily." I hesitated, wondering whether to share. "One time," I continued, turning to look at Jim and holding his hand tighter, "when I was in eighth grade, I was expelled for a day from school—for *whistling!*" I bit my lip. "But it wasn't me! I can't whistle a note! I just sat in the back row with the boys who

were always cutting up." My voice was shaky. "The spelling bee was that very afternoon! I missed it after studying the dictionary the entire year. I thought I'd have my picture in the *Des Moines Register* and go to Washington to shake the president's hand. I cried all the way home and ran to the sleeping porch, so mother wouldn't hear. She found me, and asked what had happened. Then she called my great-aunt Margretha, who scolded Mother for not marching to the school to set things right."

"Oh—for cripessake! I'll bet you were both miserable," Jim said.

"We were—I couldn't talk about my feelings. I covered them up, pretending it didn't matter. But I felt sorrier for Mother . . . she felt so guilty for not defending me."

Jim nodded. "I know—feeling guilty is the hardest thing."

"That's the problem," I blurted. "I'd feel guilty about running off to Yale. My parents gave up so many things. For a long time we couldn't afford a car—I remember my father hitching a ride to work with the milkman during blizzardy weather! Still, they found the best string teachers in Iowa for us, no matter what it cost." I twisted my handkerchief nervously. "They'd make it possible for me to go—but how can I ask?"

I turned to Jim. "I'm glad I can talk about this with you—it's been bottled up in me for so long."

"Hey," he said, and reached for my other hand, "as far as Yale is concerned—it will *always* be there." He chuckled. "Yale will never disappear."

I took a deep breath.

"I have to admit, I really wanted to impress people, too—like my aunt Cosette. That people would be saying, 'Did you hear?'—"

I was silent as cars roared past the bus. Along the parkway, children were skipping rope and chasing squirrels. I saw one boy climbing up a tree after one. I'd loved climbing trees, too, finding my own fantasy world in the branches. What a carefree life it is when we're young, following our whims, thinking only of the next exciting moment.

The sun was beating down; it was hot. Jim took off his heavy navy hat, smoothed his hair, wiped his forehead, and put his hat back on. Had I been blinded by the glamour of these past few months? Caught up in myself? I recalled the words of the lady in the yellow dress. *"The true measure of a person's success is to be a person of value."*

I knew people of value, people who kept their promises, people who were kind, people who were loyal. I

was surrounded by them: my best friend, Marty; my teacher, Mr. Koelbel; and especially my family, who had devoted their lives to my well-being.

The bus rattled to a stop. We stepped off and stood there for a moment on the sidewalk. For a few minutes I couldn't speak. Suddenly, more than anything, I knew what I wanted.

"Having second thoughts?" Jim asked, smiling at me.

"How did you guess?"

"I know you better than you think," he said, touching my arm. "You're going home?"

I nodded.

As the Riverside bus pulled away from the curb, I threw my arms around Jim and kissed him in broad daylight. I was vaguely aware of people passing, horns honking, and someone bumping into us, saying, *Lucky guy.* I didn't care. This was good. This was right, and I felt my Norwegian heart melting.

I kissed Jim once more and took his hand in mine, squeezing it tight. And together we walked into the park.

Summer *After* Tiffany

In the winter of 1945, Marjorie Jacobson returned to New York City to spend New Year's Eve with Jim. While there, she visited her friends at Tiffany and purchased some Spode china plates that she still has today.

Later that winter Jim came to Story City, Iowa, to meet her family. By then he was an ensign in the navy, and he left for the Pacific after the Story City visit. During her senior year at the University of Iowa, Marjorie met William (Bill) Hart, and they fell in love and were married on December 20, 1946.

After graduating from Iowa, Marjorie was an instructor at the Music School at DePauw University in Greencastle, Indiana. There, as a cellist, she performed

and toured with the Aeolian Trio, and taught piano and cello. She remained at DePauw during the 1946–1947 academic year before moving to Estherville, Iowa, where her husband began his career as a dentist.

Marjorie gave birth to her eldest daughter in 1949, and had a son in 1951, leaving little time or opportunity to continue her musical life. When the Korean War began, the Hart family moved to San Diego, California, to honor her husband's military commitment. After his tour of duty in Korea, they settled in Del Mar and San Diego, where William Hart built his dental practice, and they added two more daughters to their family.

While her husband was in Korea, Marjorie saw a small note in a local newspaper about a "doctors' orchestra." She joined and made many musical friends, some of whom she still plays with. Marjorie joined the San Diego Symphony in 1954, and the Starlight Opera. She also performed during that time with a number of Hollywood luminaries, including Peggy Lee, Liberace, Sammy Davis Jr., and Nat King Cole.

She went back to school in 1965, earning her master's degree in music and music performance from San Diego State University. She joined the music faculty at the University of San Diego in 1967, and performed with the Alcala Trio. Three of her four children went

on to graduate from the University of San Diego—one in music—and the other graduated from Santa Clara University. Marjorie became chair of what was then the Department of Fine Arts in 1978 and retired in 1993 as professor emerita.

Marjorie retired from professional cello performance in 2004 when she turned eighty years old—celebrating her birthday as soloist with the University of San Diego Symphony, with all of her children and grandchildren sitting in the front row. She performed on her Carlo Giuseppe Testore cello—like the cello she'd admired during her summer in New York City—which she'd purchased in 1970. She still plays three or four times a week with several string quartets.

William Hart passed away in 1981, and she remarried in 1986. She and her second husband, Peter Cuthbert, now live in La Mesa, California. Her four children have nine children, and Peter has three daughters and five grandchildren.

Martha "Marty" Garrett graduated in 1947 from the University of Iowa with a B.S. degree in finance. She then moved to Chicago and worked for the Continental Illinois National Bank & Trust Company of Chicago—the largest bank under one roof in the United States, as Illinois had no branch banking at the time. She lived

in a girl's club on the University of Chicago campus, where she met her future husband, Paul Jackson, who was majoring in mathematics, finishing his education after serving three years in the army in Europe.

They were married after his graduation in June 1949 and moved to Hartford, Connecticut, where her husband became an actuary with the Aetna Life Insurance Company. In 1964, he joined the Wyatt Company in Washington, D.C., and they moved to Bethesda, Maryland, where he was an actuary for pension plans for GM, IBM, Penn Central, and AT&T, among others, and was on many actuarial committees. Through his job they traveled all over the world.

They were the proud parents of three sons, each of whom was born while they lived in Hartford. Marty balanced motherhood with being active in volunteer work through the Junior League, work she continued after her move to Bethesda. Most recently she was active on the Women's Board of the American Heart Association that holds an annual fund-raising luncheon and fashion show every February for twelve hundred guests. The board has raised $3.3 million for the lifesaving research work of the American Heart Association since the event's inception over five decades ago. Her hobbies were golf, tennis, and paddle tennis, which

she enjoyed playing with her husband and friends at Congressional Country Club. Now she enjoys her grandchildren and bridge. After fifty-four years of marriage her husband died in 2003.

Marjorie and Marty remained lifelong friends; Marty's accurate recall of details from the summer of 1945 were invaluable to the writing of this book.

Margaret (Mickey) Shuttleworth Vernallis graduated with a Ph.D. in psychology from the University of Iowa, and during her lengthy career was a psychologist and professor of clinical psychology at California State University, Northridge. She has three daughters, a stepson, and several grandchildren. Currently living in San Fernando Valley, she is a Sierra Club leader and a music lover, and enjoys being with her family.

Katherine and Dick Munsen still live in Story City. They collaborated on the book *Bail Out Over the Balkans*, the story of Dick's miraculous survival during WWII, and Katherine has also authored six other titles. Philip Jacobson was director of finance for Global Missions, ELC Lutheran Chruch. He and his wife, Diane, live in Bloomington, Minnesota. Marjorie sees both families several times a year, and both her sister and brother still serve lutefisk and lefse for Christmas dinner. Bill Craig, a family friend who also

grew up in Story City, lives and works in Manhattan at Sotheby's International Realty.

Hans Koelbel, her teacher at the University of Iowa, remained in Iowa, and he and his family visited Marjorie one summer in Del Mar.

Marjorie inherited the Royal Doulton Old Leeds Spray china from her mother, and still has her beloved Spode teapot and Tiffany brochure, given to her on her last day as a page at Tiffany.

While Marjorie shared many of the stories and pictures with her parents from her summer in New York City, she never revealed her opportunity to transfer to Yale. And she never regretted her decision to return to Iowa.

After her 1945 trip to New York City, she didn't return to the Fifty-seventh Street and Fifth Avenue Tiffany store until 2004.